THIS I REMEMBER

This I Remember

BY
KARL GEIRINGER

WITH
BERNICE GEIRINGER

Fithian Press
SANTA BARBARA • 1993

Design and typography by Jim Cook

Published by Fithian Press
Post Office Box 1525
Santa Barbara, California 93102

LIBRARY OF CONGRESS CATALOGING-IN-PUBLICATION DATA
Geiringer, Karl, 1899–1989
 This I remember / Karl Geiringer
 p. c.m.
 ISBN 1-56474-045-5
 1. Geiringer, Karl, 1899–1989. 2. Musicologists—United States—
Biography. I. Title.
ML423.G313A3 1993
780'.92—dc20
[B] 92-36717
 CIP
 MN

To Martin Silver
who suggested this work and devoted much time and
effort to it, in sincere gratitude and friendship.

Contents

A section of photographs follows page 96

Preface

THE AUTOBIOGRAPHY of Karl Geiringer, once called "the man who was the history of music himself," had its genesis in a series of oral history interviews held by Martin Silver in 1984 and destined for the archives of the University of California. As a consequence of these interviews, Karl decided in 1987 to write the story of his life. Once he had made the commitment and had begun to write, he persevered tenaciously. Fortunately he was able to complete the autobiography shortly before he died.

What emerged was a vivid portrayal of his life from the turn of the century: his early years, his work at the Gesellschaft der Musikfreunde, and his encounters there with many legendary personalities such as Pablo Casals, Bruno Walter, Arturo Toscanini, and many others. That phase of Karl's life came to an abrupt end with the Nazi occupation of Austria. His emigration to America has had far-reaching influence in the world of music. As professor at Boston University for many years and later at the University of California, Santa Barbara, he inspired several generations

of students, many of whom have achieved notable recognition, among them H.C. Robbins Landon. Karl's erudite and definitive writings on Bach, Haydn, Brahms, and the Bach family form the cornerstone of works on these composers. His contribution to American musicology cannot be overemphasized, for he brought with him the heritage and the tradition of the immortal Viennese masters.

This book is no ordinary autobiography; rather, it is the story of a fascinating life spanning almost a century. It will not only be read by those who seek insight into the life of an internationally known scholar; it is also a document that captures the historical and cultural spirit of the times in which Karl lived.

—BERNICE GEIRINGER

Foreword

The following introduction was written by H.C. Robbins Landon as the foreword to Studies in Eighteenth-Century Music: A Tribute to Karl Geiringer on His Seventieth Birthday, *published in London in 1970 by Allen and Unwin. Landon, a distinguished musicologist, leading Haydn and Mozart scholar, and author of definitive books on these masters, was a former student of Karl Geiringer's whose career was profoundly influenced by his association with so eminent a scholar, teacher, and mentor. Landon founded the Haydn Society in 1949 and has edited new editions of Haydn's and Mozart's compositions.*

I F THE international list of contributors bears eloquent witness to Karl Geiringer's stature as a scholar, it perhaps does a little less justice to his extraordinary merits as a teacher, about which I would like to add a personal word.

Having been fortunate enough in the early postwar years to have studied with Karl Geiringer at Boston University, I

can attest to his brilliant and compelling method of teaching. Whether it was a class in Schubert for a hundred undergraduate students having little or no technical knowledge of music, or a specialized seminar for advanced students dealing, let us say, with Mozart's symphonies, Karl Geiringer always found the right level, the right tone, and the right way in which to bring the subject close to the students' hearts. Another factor of Dr. Geiringer's teaching should be stressed here: his uncompromising efforts to combine musical theory or, if you will, musicology with practical music-making. I remember with vivid pleasure how one day an entire undergraduate class was handed music to Dufay's *Gloria ad modum tubae*, in the performance of which I played one of the trumpet parts on a valveless D-trumpet, reconstructed from an old E-flat Confederate Army bugle. We all were expected to, and in fact did, participate in the college orchestra and/or choir; and we were encouraged, if (as was the case with me) we played in the orchestra, to perform on as many instruments as possible. I also recall that Karl Geiringer materially assisted me when I and his co-student Samuel Adler (now at the Eastman School of Music, Rochester) wished to form our own Collegium Musicum.

Karl Geiringer himself used to like to play viola in a quartet made up of his students; he also often conducted the orchestra, as he did, for instance, to illustrate his own brilliant lecture series on Haydn at the Boston Public Library in 1946-47.

All these things vastly reduced the fatal gap between musicology and the practical world of music, and his former students owe him an eternal debt for his efforts in this direction. Not for Karl Geiringer the chalk and blackboard alone: we made music at every conceivable opportunity.

Karl Geiringer was a native Austrian and, as custodian of

the famous archives at the Gesellschaft der Musikfreunde in Vienna, had already made a distinguished name for himself as a scholar when he left his native country in 1938 to go first to England and then to the United States. In company with many distinguished central European scholars such as Alfred Einstein, Curt Sachs, and Leo Schrade, he brought the standards and traditions of the Old World to us in the New, and not only greatly enriched the lives of American universities but succeeded in bringing us even closer to Europe and European thinking. Since most of us are engaged in working with some aspect of the vast tradition of European musical culture, it is obvious that the presence, in America, of men like Karl Geiringer revolutionized American scholarship in general and musicology in particular.

Professor Geiringer now lives and teaches at Santa Barbara in California which is—if I may be permitted to make a personal remark—as delightful a place for a distinguished European scholar to finish a long and distinguished career as I can possibly imagine.

—H.C. ROBBINS LANDON

Acknowledgment

W E ARE VERY GRATEFUL to our father for writing this book when he was already eighty-five years of age. We are also very grateful to Bernice Geiringer. There is no question that without her encouragement and assistance what began as a series of taped recollections with Martin Silver would very likely never have been reworked and extended into the present manuscript.

In his formal publications about music, our father maintained a scholarly, educated tone. However, in the present work, which he gave to us as a Christmas present shortly before his death, he included more personal comments, and wrote in a much more "familiar" style. As he was clearly pleased with the end result, referring to it frequently as we sat with him each day in the hospital during his final illness, we, along with Bernice, decided to share this wonderful personal portrait with a larger readership that knew him and his first wife, Irene, only through his scholarly books and lectures. We think that it is most fitting that the version that he liked so much has not been edited in any detail, so that a

larger readership can be reminded, or gain a broader view, of Karl Geiringer, the person, as well as Karl Geiringer, the musical scholar.

—MARTIN AND GEORGE
Karl Geiringer's sons

Early Life

I AM A MUSIC historian, or a musicologist as it is called in the United States. A musicologist is usually defined as a professional musician who cannot play an instrument well nor sing or compose music, but who delves into the history of music. Another definition is "a person who indulges in words without songs."

My good friend Martin Silver has been urging me to set down on paper my memoirs, and my wife, Bernice, strongly supports the idea. I am very reluctant to do it. I am more than eighty-nine years old, my memory is not very good, and I am sure to get some of the facts wrong. However, I will try to capture some episodes and fragments of past events.

Early Youth and Family

I was born on April 26, 1899, in Vienna, Austria. My father, Ludwig, was a businessman, active in the trade of textiles.

He was very dependable and upright and worked extremely hard to support the family. I was a bit afraid of him, although he was kind and friendly to me. During my childhood he often took me for long walks, and in wintertime when it grew very cold I liked to put my hand into the pocket of his overcoat, where he held it with his own strong warm hand. My father was nearly blind, but an unfailing memory helped him to keep going and to carry on his business. He never admitted his weakness, though, and when my mother told him that she had a new dress he admired it and praised the colors and the elegant style which he could not really see. He was not able to read any more and, as he wanted to keep up with the news, we had to read aloud to him from the newspaper daily. I did this frequently, though not in a gracious manner, as I found the articles to be very boring. My father also had a helper in his office who typed letters and did some bookkeeping. Papa supervised this work with the help of his unfailing memory; even mistakes in bookkeeping were detected by him immediately, for he kept all the numbers in his head. In our apartment he moved about quite freely as he knew exactly where each object stood; but if we left a chair away from its usual place he invariably bumped into it. When he was in the street, of course, he always needed help, which I frequently provided.

My mother, Martha, was a very warm and art-loving person, receptive to beauty and goodness. Her health was not very good. She was frequently ill but only rarely indulged in proper rest as she had the responsibility of the family and also helped my father with his business. Mother was very fond of music and played the piano well. My later choice of music as a profession was partly determined by her own leaning.

I was the youngest of four children. My brother Ernest was seven years older than I, my sister, Hilda, six years and

my brother Paul five years older. As long as I was very young they paid little attention to me. My mother, on the other hand, fussed over me very much. I was a rather sickly child, apt to catch frequent colds with high temperatures. The doctor thought I had a weak heart, and I was frequently kept in bed with a contraption circulating cold water over my chest. This was supposed to strengthen my heart.

The financial circumstances of my family were, at that time, very limited. I remember living for years in a small apartment on the fifth floor in a noisy street in Vienna's Eighth District. Of course the house had no elevator, and we constantly had to carry all necessities up and down the steep stairs. The apartment consisted of three rooms. The largest of them served as our living and dining room. It contained a piano and a typewriter which my mother used for my father's business correspondence. One of the walls was occupied by a divan on which my sister slept at night. The second room, with a single window to a narrow courtyard, belonged to my two brothers. The third room was my parents' bedroom. There I slept on a sofa. We had a kitchen containing a coal stove, with a window opening into the same courtyard as that of my brothers' room. The adjoining bathroom had a water heater fired with coal. It had no outside window, only an opening into the kitchen. The room served also as the bed-room of our maid. (At that time even a family with very little financial means kept a maid as a helper.)

To strengthen my health I was frequently sent out of the city into the country. I remember having lived for a while with a step-brother of my father and later with a sister of my mother. Both of them were married and had children of their own, but they did not mind a temporary addition to their family.

When the proper time came my mother taught me how

to read and write, as well as the elements of arithmetic. Afterwards I had to take a test in a public school and it was found that I had kept up with my colleagues in class. When I was sent to school the following year I was nauseated and felt so miserable that my parents allowed me to do my work at home and not to go to school. This situation continued from first through primary and later through secondary school. I had all the textbooks that my classmates used, but I went to school only rarely. Most of the time I worked on my own, and if I had a really difficult mathematical problem I took it to my sister, Hilda, who helped me with it. My parents only saw to it that I took all the important tests with the rest of the class and was awarded good grades.

From time to time I was still sent into the country. At the age of sixteen I spent several weeks in Ramsau, a remote alpine village in southern Austria, resting in the sunshine and drinking huge quantities of milk fresh from the cows.

This stay had a rather dramatic ending. After a month of doing nothing I felt rather bored and decided to have a little distraction. The Ramsau was a valley located high up in the mountains, and the impressive summit of the Dachstein looked close and inviting. I was well rested and felt strong, thus I decided early one morning to climb to the summit. I just took my windbreaker and a little food and went on my way. The ascent seemed quite easy and I quickly reached an elevated plateau. There, however, I met an unexpected obstacle. The comfortable part had ended and in front of me was a large and rather threatening glacier which separated me from the rocky summit. Fortunately a group of tourists with a mountain guide passed me and I decided simply to follow them on their ascent. The grumbling guide was pacified by me with the help of a little tip and he thus conveniently overlooked my presence.

When we were already rather close to the rocky summit and there was no longer any problem of finding my way, I suddenly realized that I was very tired. It was an extremely hot day, and I simply lay down on my windbreaker and snoozed a bit in the warm sunshine. When I awoke the guide and his small group of tourists had disappeared, but I continued on my own. I easily reached the huge pile of rocks that formed the summit of the mountain. This last part of the ascent seemed to offer particular difficulties. Huge iron nails forming a kind of ladder were embedded in the rock, and there was also an iron cable to hold on to.

Before I even began the climb I noticed two men and a boy near the summit. They were huddling in a little cave next to the ladder, obviously in distress. I did not know what had happened to them, but I was very frightened. Fortunately I saw a mountain hut on the other side of the glacier with some tourists sitting in front of it. Heedless of the danger of crevasses, I dashed down to them and told them that obviously an accident had happened to some tourists. Quickly, two mountain guides who happened to be in the group went on their way to the rescue of the tourists. Much later I learned that the accident I had witnessed was caused by the weather. A thunderstorm was threatening on this very hot day, and as the tourists were standing on the ladder, with iron nails in their shoes and holding on to an iron cable, some of the atmospheric electricity had gone through their bodies, paralyzing them. I was told, however, that after their rescue by the mountain guides they gradually recovered from the electrical shock.

My own experiences on that day were not yet over. A large village was clearly visible from the hut, and the descent on a slightly sloping path did not seem difficult. Thus I decided late in the afternoon to go down and spend the

night in the valley. While I was on the descent the weather broke. A heavy rain started, and presently it was pitch dark. At that time I noticed also that I had forgotten my windbreaker at my place of rest in the morning. Soon, therefore, I was completely soaked. To add to my misery I slipped on wet leaves, falling rather unpleasantly to the ground. It took me a while to get up again and to resume my walk. By that time I was dead tired and didn't know exactly what I was doing. After quite a while, however, I noticed that the trail was no longer descending but rather ascending. Eventually, to my horror, I realized that I was in the process of climbing the mountain a second time. While lying on the ground in full darkness after my fall I had completely lost my sense of direction. It was two o'clock in the morning when I finally reached a pleasantly dry and warm bed in the village inn.

In another summer vacation I was sent to Merano, a village in the southern Tyrolean mountains which, after the First World War, had become a part of Italy. There again I just had to rest, eat well, and enjoy the balmy air. This treatment was meant to strengthen my lungs and heart. Gradually this had the desired health effect. I grew stronger and more resistant to attacks of disease. I loved mountain climbing and skiing and playing tennis. Skiing, incidentally, at that time was quite different from what it is today. No provision at all was made for indulging the sport. We had to carry wooden skis up the mountain on our shoulders or, at best, attach some sealskins to the underside of the skis which would provide some traction, helping on the ascent. When we went down the steep and narrow summer trails we used only a single long pole to negotiate the difficult descent. Our method was very crude, but effective. If we wanted to make a turn we slammed the pole into the ground and held on to it, thus comfortably circling it.

My father's financial situation gradually improved. We moved into new, much more roomy and comfortable quarters on the second floor of a much nicer, newer house in the Sixth District of Vienna. My father had rented two adjoining apartments and, with the landlord's permission, broke down the wall between them. Thus we had now a large and pleasant six-room apartment. One room served as our dining room, one as the living room with mother's piano, the next as my father's office. The next room was given to my sister, then followed the room of my two brothers, each having its own desk and its own closet. Next came the bedroom of my parents. I had the choice of sleeping on the sofa in my parents' room or else on the sofa in my father's office. I did not like either, and made my own choice. Our apartment had, as a result of the former separation, two bathrooms and two kitchens. One of the bathrooms was transformed into the maid's room and there was still the second kitchen unused. I therefore took it over as my private studio. It had a stone floor, which my mother covered with a rug. A folding bed was moved into the room and was rolled into a cabinet in the daytime. There was also an unused coal-burning kitchen stove, and it served as my desk. The kitchen window opened onto a narrow courtyard with another kitchen window opposite, only a few yards away. In order to get some privacy I pulled the wooden cabinet over the upper part of my bed at night. I was very happy in my own little kingdom and lived there for several years.

BEFORE going on in my narrative I would like to say something about my siblings.

My oldest brother, Ernest, was like our father—business-oriented. My parents, who strongly believed in a bit of foreign education for their children, sent him to Paris for

studies at the École des Hautes Études Commerciales. After a year he returned and went to work in a small bank in Vienna. At the same time he started studying at night school and eventually was able to earn a Doctorate of Law. In the bank he fell in love with his secretary, Lucy. I remember a strange walking tour through the Austrian Tyrol with Ernest and Lucy, her father accompanying us as a guardian and I, as a small boy, being taken along for the amusement of all three of them. Eventually Ernest and Lucy were married. They had two children and lived happily together until Lucy's tragic death of hepatitis, which she contracted through the transfusion of contaminated blood during an earlier surgical operation.

Ernest was a great mountaineer; he particularly loved rock climbing and made a number of spectacular ascents in the Austrian-Italian Dolomites—some of them with a guide, others by himself. Ernest was also a great friend of music and played the piano rather well. When I was nine or ten years old he discovered that I had a nice and true soprano voice. He did not tire of playing the accompaniment of Schubert and Schumann songs or of Loewe ballads for me, which I sang with gusto. We also performed duets for violin and piano together, as I had started to take my first violin lessons around that time. He was particularly kind to me as a little boy and once even took me on a trip to Paris, introducing me to the wonders of the city he loved, in particular the incredible treasures of the Musée du Louvre.

The poor financial situation in Austria caused several fusions of banks, and my brother was repeatedly forced to change his position. On the side he did some financial advisory jobs for family and friends. Our father was particularly impressed by his commercial astuteness, and consulted him frequently. Occasionally Ernest also worked for a Mr.

Weinmann, one of the richest men in Czechoslovakia, who owned a large part of the coal mines in northern Bohemia. Mr. Weinmann eventually asked Ernest to work for him as his permanent financial advisor. My brother did so and remained in the services of the family up to his death. I, myself, have always asked for his help in business matters and for many years, even after I moved to America, he has reviewed my income tax returns every year. Moreover, almost all the very few commercial shares I bought were chosen according to his recommendations.

My sister, Hilda, was probably the most strong-minded of the four of us. She frequently had more-or-less serious arguments with my parents, and usually in the end she did things her own way. She was a beautiful woman, and men stopped and looked around in the street when she passed. She decided to go into science and studied mathematics at the Vienna University, which was very unusual for a woman at that time. Her main teacher, Professor Wirtinger, was quite impressed by her achievements and prophesied a great future for her. Eventually Hilda found Vienna too confining and moved to Berlin. There she worked at the university as an assistant to the highly respected and prominent professor of mathematics and aviation science, Richard von Mises. Presently Hilda fell in love with a colleague of hers, a talented mathematician, Hans Pollaczeck, and they got married. The result of this union is my dearly beloved and charming niece, Magda Tisza. However, Hilda and Hans did not stay together very long. In less than a year they were divorced. Hilda was more successful in her university career. She became Privat Dozent, which is like assistant professor in this country, and was on her way to excelling in academic life. Eventually she became personally attached to Professor von Mises and they remained intimate friends ever after. At

the end they even got married, although they only rarely were able to live together.

When Hitler came to power almost the whole intelligentsia of Berlin left. Hilda went to Brussels, Belgium, first and later to Istanbul, Turkey, where Kemal Pascha, the "Atatürk," the leader of both a political and mental revolution, had built up a powerful university life. Hilda worked happily for years in Turkey. After the death of the Atatürk, however, the reform movement broke down in Turkey and her position lost its attractiveness. Hilda came to America around 1940, where she first taught at Bryn Mawr College. Later she became head of the department of mathematics at Wheaton College in Massachusetts. By that time Mises had also arrived in this country and was a professor at Harvard University. The two remained not only in personal but also in close scientific contact. After the premature death of Professor Mises, Hilda started to work at Harvard, where she completed two books that her husband had left unfinished. She gradually became a well-known, almost famous mathematician in her own right, and I was not surprised when, in 1988, two different mathematicians in Vienna asked for biographical information from me about my sister as well as her photograph. One needed them for a history of mathematics, the other for a book on women in science.

Hilda was, however, anything but a bookworm. She loved nature and mountain climbing, and we frequently spent our vacations together in the Swiss or Tyrolean mountains. We never spoke about mathematics, but chose only topics of mutual interest. Hilda knew enormous amounts of German poetry by heart, had read everything, liked to visit museums and go to concerts, though she had no ear for music at all. She visited us several times in Santa Barbara and it is tragic that she even succumbed here in the Cottage Hospital in

1973 to a vicious attack of pneumonia which she had contracted and ignored in Boston.

My brother Paul was the only member of the family who had technical abilities. He could fix almost any broken object, and if there was a problem with the telephone or an appliance he immediately found the cause and made the necessary repair. He was an ardent photographer, developing and printing his own pictures. Paul studied at the Vienna Technical University and then entered the services of Uncle Isidor, a brother of my father, who was a very good engineer.

Isidor was a bachelor and took a fatherly interest in the younger girls of the family. He once took Hilda and one of our female cousins on a trip to Egypt, which both girls tremendously enjoyed. Isidor was a very kind and generous man but sported bad and boorish manners. He had a great sense of humor and liked to tell funny stories; thus, for instance, he related that he slept for a while in the same room with his father, who always complained that he was such a light sleeper and that the young boy dreadfully disturbed him. One night Isidor came home late and in the darkness knocked over a little table, which fell to the floor with a dreadful clatter. Anxiously he listened to his father, who did not say anything. Next morning he asked him rather innocently, "Did you hear me last night?" "Of course I heard you," was the prompt answer. "You took your shoes off before you came to the door and went on tiptoe to your bed to undress in the dark. I hear even the slightest sound." Another time when I mentioned to Isidor that my little son, George, looked just like me he said consolingly, "Don't you worry, he will outgrow it."

My brother Paul was not only a good engineer, but also a good businessman. He was quite successful in Europe and later even more successful in this country, where he came in

1940, very soon after Hilda and I. His wife, Nana, was a charming lady and an accomplished pianist. They lived together very harmoniously until Nana was felled by a terrible disease, cancer of the tongue, which killed her after years of suffering. She was a very amusing person whom I loved very much. She often made humorous remarks, and when my brother once went on an extended business trip she admonished him, "Remain faithful to me. Don't try to get for money what you can get at home for free!"

LET me now return to my own childhood. I recall that late in the spring of every year a kind of revolution started in our household. Huge cases were fetched from the attic and filled with bedding, cooking utensils, canned food, and other necessities of life. They were sent by slow railroad to the place in the country where we were to spend our summer vacation from the end of June to early September. My father usually had to stay in town attending to his business and was only able to visit us occasionally. We were joined, however, by the family of my aunt, a sister of my mother, to whom she felt particularly close. Aunt Irene had married a Hungarian lawyer, Dr. Simon Gold, and lived in Budapest.

Uncle Simi, as we usually called him, was very friendly to us children. I remember that one summer we stayed in a very primitive peasant house in northern Bohemia. The toilet in this cottage consisted merely of a large room with a deep ditch underneath, covered by a wooden board with two round holes for the use of the facility. A wooden lid covered each hole to prevent the escape of bad odors. My uncle often forgot to lock the door of this room and once, when I dashed in, I found him there reading a newspaper while performing his business. I wanted to retire quickly but he called out in the most friendly manner: "Come in, come in, there is

room for both of us." Rather reluctantly I followed his invitation, but pretty soon we sat companionably next to each other engaged in a pleasant conversation.

My uncle and aunt had three children, one of whom died in early infancy from a kidney problem caused by a neglected cold. The oldest sibling, Ella, was close in age to Ernest and Hilda, and they were both very fond of her. The three of them did many things together. On the other hand, my constant companion was the youngest brother, Stephen, usually called Pista, who was a few months older than I. We were both terrors and were often compared to the notorious bad boys in Wilhelm Busch's famous children's story of Max and Moritz. One of our favorite occupations was to disappear under the table at mealtimes and pinch the older members' calves with sugar tongs. The difference between Pista and me was, however, that he was always neat-looking in appearance and polite, while I was scrubby and ill-mannered. Usually I was unfavorably compared to him, which did not greatly bother me, however. One of the few Hungarian phrases which I picked up at that time I learned when my cousin Ella said to me in disgust, *"Utalotos agy te"* (you are very naughty). Much later in life I became a very good friend of Ella's, and I greatly admired and loved her. She was a very smart, upright, kind, and helpful person.

War Years

My idyllic childhood life ended soon after the outbreak of the First World War in 1914. My father did particularly well financially at that time. His business flourished because his textiles were in great demand for the equipment of the armies. He bought two beautiful adjoining old houses in Vienna's suburb of Sievering. They stood in a large old gar-

den with magnificent trees. Father rebuilt the houses com-
pletely and assigned the smaller of them to Ernest, Lucy,
and their two children, Helen and Frank, while in the other
house my parents and I lived. This was a wonderful place
with a large dining room and a very big living room with a
smaller library on the first floor. On the second floor there
were, on the garden side, my parents' bedroom, a dressing
room, and bathroom; on the street side was my own apart-
ment, consisting of three rooms and my own bathroom. On
the third floor was my father's office, the room shared by
two maids, and a third bathroom.

Toward the end of the war my father also bought a small
farm in Styria near the capital city of Graz. Our property
was not large, but it had pigs, cows, and horses, and large
fields in which we grew both wheat and rye. There were also
pastures for the cattle to graze. After the war I spent many
happy summer months there milking the cows and working
in the fields. The farm also had a big orchard with apple
trees. These apples we pressed in our own little mill into
cider which we allowed to ferment and acquire a slight alco-
holic content. The farmhands, whom my mother fed, drank
it constantly, as they claimed that water was not good for
their stomachs. On the farm I also learned to get along with
horses. I was quite adept at driving a horse-drawn carriage
and at riding horseback.

My life had not been quite as pleasant, however, during
the war. Very quickly, shortages developed in everything:
bread, meat, and even clothing and shoes were rationed.
Prices for all the necessities of life went up rapidly.

All three boys in our family had to go into the army. My
brother Ernest quickly advanced to become an officer, while
Paul was soon excused because he did important war work as
an engineer. I, myself, was recruited into the infantry in

1916 when I was barely seventeen years old. I was rarely as unhappy as I was in the following year. On account of my youth I never did any actual fighting; however, the training time in Vienna was martyrdom for me. I did enjoy the physical exercise, and received much better food than my mother had been able to provide at home. On the other hand, I was repulsed by the coarseness of my mostly older colleagues, the constant talk about women, and sleeping in huge noisy dormitories together with dozens of unwashed peasant boys. Even before the basic training was finished I was moved to Pressburg (now Bratislava in Czechoslovakia), and there I was assigned to sentry duty. Every day and night I had to stand for two hours with a rifle on my shoulder and then I could rest for four hours, thus doing sentry duty for eight hours daily. I usually stood in front of the military headquarters building, but also occasionally in the garden of the colonel to protect his fruit trees and vegetables from thieves. However, when I felt unobserved I myself ate some of the goodies which I was meant to protect.

In spite of these occasional pleasures, I found life in Pressburg intolerable. I never got enough sleep during the four hours which I could spend on a wooden bench between two turns of duty. It was impossible for me to fall asleep because I was terribly bothered by bedbugs and lice, which were everywhere in the rooms I had to share with other soldiers. Moreover, standing sentry at night in front of an almost empty building was boring and frustrating. One night I could not bear it any more. I simply took my gun off my shoulder, leaned it against the wall of the building, and went to a friend's apartment, where I took a bath and went to sleep. Next morning, of course, two soldiers came and arrested me, and I was thrown into prison. I was not yet quite eighteen years old at that time.

The prison consisted of a large room which was filled with other miscreants who were unwashed, dirty, and smelly. The worst was that each soldier going to prison had to bring his own straw-filled mattress, which he put on the floor as his own bed. Thus the room was covered with mattresses, and I could only sit or lie on my own mattress, as I would otherwise intrude on one of my fellow prisoners' domain. For about six weeks I had to endure this most unpleasant situation. Then one day the door of my prison suddenly opened, and without any comment or explanation, I was set free. I found out later that my father, who was horrified by the event, had pulled all the strings available to him, which resulted finally in my release. From then on my military life changed completely. I was returned to Vienna and assigned to regular office duty, which I found not unpleasant. I was even allowed to live at home, and I commuted to the office with the help of the streetcar. My boss was a civilian, an ordinary businessman, and I got along with him easily. I even advanced in rank and was no longer a private, but a non-commissioned officer. Even after the war had ended, they did not let me go. I had to stay in the service until well into 1919. The only real fighting I had seen during these years was, however, in front of Vienna's House of Parliament, when the socialists declared Austria to be a republic while the conservatives attempted to protect the collapsing Austrian Empire.

Years of Study

An enduring benefit which I got from the war years was that they opened my eyes for my later choice of profession. I had started to take violin lessons at the age of nine or ten; at the

same time I also did quite a bit of singing. During the following years I continued practicing the violin, and played a great deal of chamber music. In the summer months I played a large portion of the violin and piano literature with a girl-friend who was an accomplished pianist. I also had a piano trio at home, with my mother playing the piano and my brother Paul the cello. However, we eventually found Paul was not good enough a player and replaced him with a professional cellist, who also served as our coach. I also liked to play string quartets very much and never missed an opportunity to join forces with other amateurs. As there was always a shortage of viola players, I also learned that instrument, which I didn't find difficult, for it was only a bit larger than the violin, and reading the unfamiliar alta clef was no particular problem either.

During the long, boring hours of the earlier part of my military life, I avidly read a popular history of music, which my parents had presented me. I found the subject fascinating and carried the work on after I left the service. I decided to also study the theory of music and went to a friend of the family, the composer Hans Gäl, who was young himself but who had already written a very successful opera. Hans became my very thorough and pedantic—though uninspiring—harmony teacher. I also needed training in counterpoint, and approached a highly respected older man who was a professor at Vienna's Hochschule für Musik. Professor Stöhr examined me and was willing to accept me as a student, but I was quite unable to meet his financial demands. "Don't you worry," said Stöhr. "I will send you three of my own students and you will pass on what you have learned from me. The payment you receive from them will be given to me and you will then owe me nothing." This I accepted. I was only a few lessons ahead of my own pupils and, as I was

forced by this arrangement to go over the same material several times, I learned the subject extremely well.

I presently decided to make quick use of my newly acquired abilities and took the Austrian teacher's examination, which authorized me to teach music at primary and secondary schools in Austria. At this examination I had no difficulty with the history and theory part, but matters did not go so smoothly for my violin playing. I did well on the Mozart G-Major Concerto, but the far more sophisticated Mendelssohn E-Minor Concerto was too much for me, and the examiner, the famous violinist Arnold Rosé, was not pleased at all. Nevertheless, I made the grade. Incidentally, my examiner in the history and theory of music at that time was Professor Eusebius Mandyczewski, the director of the library and archives of the Gesellschaft der Musikfreunde, who was later to play an important part in my life.

At that time my parents thought it was time for me to decide what I would make of my further life. My father would have liked me to take over our farm in Styria, and I felt greatly attracted to the rural life. However, I had always thought that I would become a medical doctor. In the end I chose neither of these professions. My success at the teacher's examination had opened my eyes, and I decided to carry on my theoretical studies in music. With the somewhat reluctant permission of my parents, I enrolled at the Vienna University as a student of music history and theory.

A new intellectual world opened up to me in the ensuing years. My main teacher was Professor Wilhelm Fischer, an expert in the field of eighteenth-century music. He had not published much, but the little that had appeared in print was of classical perfection and even today, well over sixty years later, is still generally accepted and not superseded by more recent research. Fischer was a very enthusiastic lecturer. He

illustrated his talks constantly with examples, as he played the piano fairly well. Through him I acquired an undying love and admiration for the great works created during the eighteenth century in Germany and Austria. Guido Adler, the head of the department, introduced us to the mysteries of Gregorian chant and the earliest phases of our present musical notation. Later, Fischer also taught us mensural notation of the thirteenth to sixteenth centuries. I was assigned the transcription of the *Missa Cucu* into modern notation. The name of this piece was derived from the fact that its cantus firmus was based on the call of the cuckoo bird. This Missa formed a part of the so-called *Trent Codices*, seven volumes of manuscripts which are considered to be the most important body of polyphonic music of the fifteenth century. These were found in the Cathedral of Trento (now Italy, but before the First World War part of the Austro-Hungarian Empire) and brought to Vienna where they were in the safekeeping of the University. I kept my transcription for many years and had almost forgotten it when my dear friend, Gustave Reese, borrowed it from me for his History of Renaissance Music and never returned it.

After three years of university studies, my parents and I decided that I would continue my work in Berlin. There I met not only a new set of teachers, but also a much more fascinating cultural atmosphere. My first teacher was the famous Hermann Kretzschmar, who was at that time already an old man. Kretzschmar conducted a seminar in which the students always had to illustrate their reports with extensive examples on the piano. As soon as the playing began, Kretzschmar invariably fell asleep and awoke only when the performance stopped. When my turn came I heavily bandaged my hand and pretended to have suffered an accident so that I wouldn't have to perform. I was a very poor pianist,

having learned to play the piano only rather late and never having practiced properly.

Equally unavailing was my work with Johannes Wolf. He was the director of the music section in the Preussische Staats Bibliothek, one of the world's greatest libraries, and famous as a scholar and expert on earlier musical manuscripts. Wolf was a charming man and remained my benefactor and friend for a long time, but his lectures were deadly. What he gave us was mainly footnotes from his research, endless numbers of codices, dates, and meaningless facts.

My real inspiration and the greatest influence on my further intellectual development came from Curt Sachs, the director of the fine collection of early musical instruments at the Hochschule für Musik. Sachs gave me a table and chair in his own office and allowed me to assist him in his cataloging of the rich holdings of his collection. I also observed with fascination how some of the early keyboard instruments were restored to practical use. Sachs, who was very good to me, also took me to his home to study in his large library, which contained books from all fields of the arts.

I remember sitting on the porch of his comfortable home enjoying the company of his baby boy, who lay in a basket near my own chair. Once the very active child upset his own basket, fell to the floor, and yelled to high heaven. I was completely helpless and didn't dare touch the baby until Mrs. Sachs came to our rescue.

Sachs had in earlier years majored in the history of art and only later decided that his real vocation was in the field of music. He was just as well versed in art history as in music history. One of his many highly important publications was *The Commonwealth of Arts*. Sachs was a speaker of breathtaking skill. When he lectured one always had the feeling that he was reading from a well-researched book. Actually, I

never saw him use a manuscript, even when he offered highly technical papers at a scientific meeting. He was an immensely popular docent, and his classes at the university were so popular that one had to arrive very early to secure a seat.

I also attended the choral rehearsals of the famous conductor Siegfried Ochs at that time. He was a wonderful example for the voice students of the Hochschule, and his performances of baroque and classical music were rightly famous. Through observing his conducting technique closely I acquired my own love for conducting musical performances, which I have never lost. I also took part in activities which were not connected with music. I frequently visited the theater, especially performances in the Deutsche Theater directed by the famous Max Reinhardt, and I spent as much time as I could afford in the Kaiser Friedrichs Museum with its incredible treasures of German, Italian, and Dutch works of art.

My living quarters in Berlin were more than modest. I rented a little room in the subterranean apartment of the caretaker in a large apartment house in the suburb of Friedenau. I ate most of my meals in vegetarian restaurants, not because I was a vegetarian myself, but because it was cheap.

When the time came for me to choose a topic for my doctoral dissertation, I selected to investigate the use of string instruments in the Renaissance period. Unfortunately the material of wood and strings used in the construction of these instruments was not durable, and very few instruments made before 1600 have survived. However, painters and sculptors of earlier centuries, whose realistic reproductions of small objects were well known, liked to include musical ensembles or, at least, single musicians in their works of art.

This can be observed even on prehistoric items: Greek artists frequently depicted instruments on their vases; we find instruments in sculpture on medieval churches; and angels with a variety of musical instruments serenading Christ or the Virgin Mary were reproduced with a certain regularity on canvases during the Renaissance period. Thus my research on instruments built between the years 1300 and 1650 had to be based largely on works of visual art. This suited me very well, as I had always been very strongly interested in painting and sculpture.

When my dissertation was practically completed, my parents called me back to Vienna and I confidently submitted my manuscript to the chairman of the department of music, Guido Adler. However, I found a rude awakening from my dreams. Adler inspected the dissertation, studied it, and finally refused to accept it. "I am incapable of judging a work of research of this kind. This is not my field. You must try to find another professor if you want to have it accepted as a doctoral dissertation." This put me into a very difficult position. Julius Schlosser, a director of the Vienna Kunsthistorisches Museum, who had catalogued Vienna's wonderful collection of Renaissance musical instruments, was the proper person to evaluate my work. However, his choice as the main reader of my dissertation was bound to completely upset my course of studies. Every student in the liberal arts had at that time to choose a major and a minor subject of research. Originally I had selected the history of music as my major and art of the Renaissance period as my minor. Now everything was changed, as the choice of the art historian Schlosser as the main reader of my dissertation made me automatically an art major with a minor in music history. I desperately wanted to graduate by the end of the school year, and I had to cram furiously in order to meet the new situa-

tion. In the end, matters did not turn out too badly, as both main examiners were well-meaning and helpful. Schlosser's oral examination was not too difficult, as I had tried to persuade him to pass me easily since Adler, the examiner in my minor field, would be prejudiced against my work.

At the music examination I used a trick common among the students of the department. We knew that one of the main features of our examination would be the printed scores of earlier music which were submitted to us. We were supposed to recognize the period and usually also the name of the composer of the work. Music at that time was mostly printed from engraved copper plates, which bore a number at the bottom for distinguishing purposes. We memorized these numbers and were usually able to "recognize" a composition at the first glance, even without looking at the music at all.

My examination was more complicated in philosophy, which at that time had to be passed by every candidate, both science and art majors, and was given by a philosophy professor. At the end of the school year the poor professor had to conduct oral examinations for several dozen students. When I presented myself to him as a candidate for examination, I found him very nervous and irritated. "I have no time at all," he exclaimed. "I have to rush to the National Library. I am sorry I cannot help you." I tried to persuade him and told him that I must pass his examination if I wanted to get my degree. He hardly listened to what I said, and dashed away with me in hot pursuit. Thus we arrived at the National Library. In the corridor he finally confronted me, "What shall I do with you?" he asked in despair. "Examine me," I said. "But how can I, here?" he retorted. "Let us go to the men's room," I suggested. And this was what we actually did. I took my examination in philosophy in front of a lava-

tory. When he was satisfied that my knowledge of the history of ancient Greek philosophy was adequate he dismissed me and did his own studies in the library. I waited patiently for several hours until he had finished and then I pursued him again on his way to the University to make sure he would sign the document I needed to graduate. Thus, by the end of the 1922–23 school year, at the age of twenty-four, I finally became a Doctor of Philosophy.

CHAPTER II

Transition

THE QUESTION arose now: What should I do with my life, and how to earn a living? Guido Adler was very nice and, although I was out of school, invited me to write the chapter on musical instruments in a monumental *Handbook of the History of Music* for which he was assembling collaborators among renowned musicologists of the world. I was probably the only unknown and certainly the youngest among the contributors to the work. I don't know whether my extensive article with its very numerous illustrations really satisfied him, but he accepted it and it was published without changes. I also published some excerpts from my dissertation in the two leading German language musicological periodicals, the *Zeitschrift für Musikwissenschaft* and the *Archiv für Musikwissenschaft*. This brought me into contact with Alfred Einstein, the renowned Munich music critic and editor of the *Zeitschrift*. Einstein was a very kind and helpful guide to my literary production, and I learned a great deal from his tactful and friendly advice.

But all this was of little practical value and provided

almost no financial return. I had to attempt something else.
The daughter of one of my mother's lady friends was married to the director of a new music publishing house. The
Wiener Philharmonisher Verlag set out to produce miniature scores of musical compositions in competition with the
old established Eulenburg scores. The new publishing house
added to each volume a preface in German, Italian, and
French and a picture of the composer. It also used better
paper, and the musical text was revised with greater care.
Moreover, a substantial number of compositions not available in the old edition was issued. I was assigned to the
French Correspondence department, and there my trouble
started. As a child I had learned to speak French well, as I
had a French governess for years. However, I was not able to
properly spell the words which I could utter fluently.
Fortunately there was a young girl of approximately my own
age in the office who kindly came to my rescue. She corrected my spelling mistakes before the director saw the letters, and in some cases she retyped whole letters. It did not
take long, however, before the little deception was discovered and I was no longer required to write French language
letters. Instead the director tried to use me as a proofreader
but here, too, my work was unsatisfactory. I did not do too
badly correcting music, but I overlooked many printing
errors in the prefaces. As a last attempt the director asked
me to provide prefaces and pictures for new volumes of the
series. This, at last, was successful. I wrote prefaces for each
of Bach's six *Brandenburg Concertos*, for Brahms's four symphonies, Beethoven's Mass in C Major, Pergolesi's comic
opera *La Serva Padrona*, and easily secured from the vast
holdings of the Austrian National Library and the Vienna
Gesellschaft der Musikfreunde the pictures necessary for all
newly issued scores.

In spite of the friendly reception which the new venture found, it did not do too well financially and was taken over by Universal Edition, one of the world's leading music publishers. All the scores and equipment, as well as the small staff, moved into the Musikverein (the building of the Gesellschaft der Musikfreunde) where Universal Edition had its headquarters. Both Irene Steckel, the young lady who had corrected my letters in French, and I were assigned to editorial work, conducting and supervising the production of new scores. Irene learned quickly and soon did excellent, reliable work, while my own not-very-strenuous efforts produced only mediocre results. I was not actually dismissed, but nobody, I myself least of all, regretted it when I resigned after a few months.

I was now again without a position and had the hare-brained idea—probably planted in me by a French acquaintance—to import French books into Austria and keep them in a depot for prompt delivery to Austrian bookstores. I soon found out, however, that this required business experience which I did not have. Moreover, the demand for French books in Austria was hardly large enough to justify the operation.

My parents did not pressure me, and I returned to research work, living without any secured income in my father's house. I collected material for a history of the lute, tracing the origin of the instrument back to antiquity and following it up through the middle ages to modern times. This rather lengthy and richly illustrated study was again published in the *Zeitschrift für Musikwissenschaft*. I undertook also another ambitious project. The Crolino Augusteum Museum in Salzburg owns a very fine collection of early musical instruments. Authorized by the museum's director, I began to assemble material for a descriptive catalog of this

valuable collection. My catalog, on which I worked for years, was later printed by the great German publishing house of Breitkopf & Härtel.

At that time Wilhelm Fischer, my former teacher, invited me to collaborate with him on an amusing little booklet. It was the custom in Vienna that at large balls the gentlemen presented the ladies with a little gift. In 1925 it was a booklet entitled *Tanzbrevier*, containing dance music, descriptions of dances, and pictures from the sixteenth to the nineteenth centuries. To me fell the task of selecting close to thirty paintings or engravings of dance scenes from the Renaissance to modern times.

My next study again concerned a work of art. In the Paris museum of the Louvre I saw a painting showing a group of both instrumentalists and singers on a stage performing for an elegant audience in a magnificent theater. I found out that the canvas depicted a festivity in honor of Louis Charles, son of King Louis XVI, becoming Dauphin in 1789. A special theater was built for this performance in the courtyard of the Louvre. The famous Italian composer, Leonardo Vinci (not a relative of the painter), provided the music based on a text by Pietro Metastasio, the leading librettist of the time. The respected Italian painter G.P. Pannini recorded the memorable event on canvas. To my pleasant surprise I found that the wonderfully rich library of the Gesellschaft der Musikfreunde in Vienna owned a handwritten copy of the score. Thus I was enabled to write a study both on the painting and the composition. The following year *La Rassegna Musicale* published the only article I ever attempted to write in the Italian language. It investigated the special liking the Dutch and Flemish artists of the seventeenth century displayed for the reproduction of musical scenes.

At this point my old professor, Guido Adler, proved helpful again. He asked me to edit a volume in the monumental series *Denkmäler der Tonkunst in Österrich* which he had started himself and directed afterward. Mine was Volume 70 of the series, and it contained works by Paul Peurel and Isaac Posch, two Austrian Protestant composers from the early seventeenth century. These two men were credited with having created "Variation-Suites," collections of dances forming variations around a central theme. I had to transcribe the early prints into modern notation and provide substantial studies about the life and work of both composers. This necessitated extensive archival studies in Upper Austria and Carinthia, where the two men had been active. The substantial articles which I eventually produced were published separately during two successive years in *Studien zur Musikwissenschaft*, a yearbook edited by Guido Adler.

I cultivated music rather assiduously at that time, forming my own little orchestra with which I practiced and performed, mostly in our own living room, which was large enough to hold thirty to forty persons. We even staged a scenic performance there of Pergolesi's comic opera, *La Serva Padrona*. Several times our little group also gave concerts in Vienna's suburbs.

At these performances my newly found friend, Irene, as well as her sister, Nelly, one year her senior, were always present. We had been seeing quite a bit of each other, even after I had left Universal Edition where she kept working for many years. We went to concerts together and to theaters and made regular weekend excursions. I learned that Irene Steckel was the daughter of a journalist who had worked in the German city of Cernauti in Bukovina, a southeastern province of the Austro-Hungarian Empire (today Russia). She was born in Cernauti, but when her mother died of can-

cer during her early childhood, her father moved to Vienna where he worked again as a journalist. According to tradition, after primary school, Irene went to attend a six-year course at a girls' lyceum. Dissatisfied with the results, she carried on her studies and took the final examination, the "matura" as it was called, at a boys' gymnasium. She presently started on her university studies with two major fields, German and philosophy. Immediately afterward she went to work, first in a concert agency and later in the Philharmonischer Verlag, where I met her.

I was more and more impressed by Irene's personality. She was very musical, played the piano fairly well, sang nicely, and had definite literary gifts. She was small and delicate yet extremely energetic. The following episode illustrates her resourcefulness. Some time before I met her for the first time, she joined a newly founded small choral group which grandly called itself Philharmonischer Chor. After a few months of membership, which she greatly enjoyed, Irene had the hare-brained idea that the chorus should perform Mahler's Eighth Symphony. This seemed to be ridiculous, since this work requires an unusually large body of musicians. Quite correctly it is often called "Symphony of the Thousand." However, Irene was unfazed at the apparently insurmountable difficulty. She decided, moreover, that only the best conductor would do for this challenging performance. She chose the famous Bruno Walter, the personal friend of Mahler who, I believe, had also conducted the symphony's world premiere. Irene told a girlfriend, who was also a member of the chorus, of her plan, and the two girls traveled to Munich, where Walter at that time was the Director of the Opera. When they expressed their invitation in the name of the chorus his first question was, of course, "Have you got the necessary resources for this gigantic venture?"

"Oh, yes, everything will be all right," was the comforting answer. Finally Walter, a bit reluctantly, agreed to undertake the gamble, and dates were arranged for the dress rehearsal and the performance.

As soon as the two girls had returned to Vienna they sent articles to all the newspapers announcing the great news that the famous conductor would direct this magnificent work in Vienna. Talented musicians, both vocalist and instrumentalists, might still be admitted for participation.

As Irene had anticipated, an enormous number of music lovers applied for admittance to the group. An expert coach conducted the auditions, and before very long an adequate body of musicians was assembled. Work on the demanding task was completed at the appointed time, and Walter arrived from Munich and declared himself quite satisfied with the preparatory work. As expected, the two performances had a sensational success, and this was the beginning of a lifelong friendship between Irene and Bruno Walter. Many years later he came to our house in Boston and we also visited him repeatedly in Los Angeles, where he lived for a long time.

I had felt "puppy love" repeatedly and even really fallen in love with a girl once before; but this was different. Irene gradually became indispensable to me, and she apparently felt the same way. I didn't propose to her; we were never engaged and I didn't give her the traditional ring. We simply set the date for our wedding and it took place in the simplest manner possible. On April 19, 1928, we met at City Hall in the presence of our parents and went through a brief ceremony. Afterwards there was a simple dinner for the close family at my parents' house, and the same evening we started on our honeymoon to Italy. We visited about a dozen of the most beautiful cities in northern and central Italy with

the greatest enjoyment, and, as the climax of the trip, stayed for almost two weeks in Rome. We also visited the little northern city of Saronno and admired the cathedral with its ceiling fresco showing a gigantic angelic concert. Christ was serenaded by several dozen angels, each playing a different musical instrument. Through photographs, I had been familiar with this fresco by Gaudenzio Ferrari for many years, and I even read a paper about it at the Vienna International Beethoven Congress in 1927; however, I had never seen the original and I was overwhelmed by the beauty of the colors and the good state of preservation of this early sixteenth-century fresco.

My parents generously invited Irene and me to take up permanent residence in their house and to share their meals whenever we wanted. We stayed in the same little three-room apartment which I had occupied before our marriage. My mother and Irene grew very fond of each other, and if there were ever little arguments between us as husband and wife, my mother invariably took Irene's side. The traditional conflicts between a married woman and her mother-in-law never arose.

Irene and I lived happily together for more than fifty-five years. As time passed we grew closer and closer. She was my secretary, but also the collaborator in my work. In the biographies of musicians which I eventually published, she wrote the biographical sections as a rule, while I dealt with the music itself. The success these books had was probably more due to her contribution than to mine.

At the Gesellschaft der Musikfreunde

A new professional opportunity opened up in 1930. Eusebius Mandyczewski, the librarian of the Gesellschaft der Musikfreunde in Vienna, passed away at the end of 1929. A reorganization of the staff that took care of the society's collections was necessary, and a new person had to be engaged to look after its numerous ancient musical instruments. I applied for the job, and my parents mobilized all their friends to furnish strong recommendations. They succeeded in securing the position for me, and I started work on February 1, 1930. My new title was Kustos (Curator) and I had three colleagues: Dr. Hedwig Kraus, the only child of the almighty vice-president of the Society, who had the title of Director; the younger colleague, Dr. Victor Luithlen, who was the Amanuensis; and Hans Daubrana, an organist from the neighboring church of St. Michaels, the Adjunkt.

I ought to mention that the Gesellschaft der Musikfreunde was, and still is, the world's most important private institution for the promotion of music. It was founded in 1812. Among its first members were Beethoven and Schubert. Its first great "protector" was Archduke Rudolph, a pupil and friend of Beethoven and brother of the Austrian emperor. Beethoven dedicated more compositions to him than to any other person and wrote the *Missa Solemnis* for his investiture as Archbishop of Olmütz. The Archduke, who was quite a talented composer himself, was quite sickly and died at an early age. He left his very extensive music library not to the Imperial Library, as was generally expected, but to the Gesellschaft der Musikfreunde. It contained, among other treasures, a large number of Beethoven's original manuscripts and a collection of Beethoven's complete works neatly written by calligraphers.

Presents to the archive of the Society gradually came from all sides. The most important bequest was made by Johannes Brahms, who was in many ways strongly attached to the Society. Brahms left his entire very large library of books, music, and original manuscripts to the Gesellschaft. As he was a passionate collector, he owned such unique autographs as the original manuscript of Mozart's great G-Minor Symphony and Haydn's six "Sun" Quartets. He also presented the Society with numerous compositions of his own, among them the original manuscript of *Ein Deutsches Requiem* and a complete set of the first editions of all his own works full of remarks and annotations made by the master in his own hand as preparation for the reprint of the scores.

The library and the museum were, however, only a part of the Gesellschaft's interests. It had its own large chorus, which was famous for tone quality and precision of performances. The greatest of the world's conductors, among them Brahms, Hans Richter, Wilhelm Furtwängler, and Herbert von Karajan were proud to conduct the Singverein, as the chorus is called. The Society also had a fairly good amateur orchestra, which likewise gave regular concerts. I myself occasionally enjoyed playing with this group.

In 1870 the Musikfreunde moved into their own very elegant and large new building, which still today forms a center of Vienna's musical life. The Musikverein, as the building is called, contains a large concert hall with a fine modern organ, and accommodates an audience of approximately seventeen hundred persons. It is beautiful and elegant and has excellent acoustics. On the hall's balcony, which runs along its full length, I had a seat just above the performers and the conductor. This seat was always reserved for me, and I could use it whenever I felt like attending a rehearsal or a performance. There was also a second, much smaller concert hall,

the Brahms Saal, well suited for soloists and small chamber music ensembles.

In earlier years the building also housed the Society's Conservatory of Music, Austria's finest music school. Outstanding vocalists and instrumentalists—among them the composer Anton Bruckner—taught budding musicians— among them Hugo Wolf and Gustav Mahler. The Conservatory gradually outgrew the building and the capacities of a private institution. The Austrian government took it over and moved the whole operation into its own building, calling it Hochschule für Musik. It still is Austria's leading music school. Instead of the Conservatory, today the Musikverein houses the offices of the Universal Edition, of the famous old piano firm of Bösendorfer, and the Philharmonic Orchestra, Vienna's leading orchestra, consisting largely of members of the State opera orchestra.

To return to my own work: The four employees of the archives and the library worked regular hours daily. Persons who wanted to study or to borrow some of the less valuable music were admitted three mornings a week. The rest of the time, however, I was undisturbed and concentrated on my work with the early musical instruments, on cataloging new acquisitions of books and pictures, and the preparation of our frequent exhibits. Most of all I worked on the preservation of earlier treasured musical manuscripts, letters, books, and pictures, which had been stored in boxes and drawers owing to lack of manpower and space to preserve them properly. Outstanding scholars and musicians like the Haydn biographer C.F. Pohl, and the Brahms friend E. Mandy-czewski had been librarians of the Gesellschaft, but they were usually engaged in so many significant musical and scholarly activities that they had been unable to take sufficient care of the huge collections they supervised. Moreover,

in spite of the riches of the collection, there was always a shortage of cash, so that much of the work needed to properly defend the treasures from the ravages of time was never done.

I was again and again overwhelmed to discover in hidden places precious objects quite worthy of being exhibited in the museum. I myself had a small but very pleasant office in the center of the Society's collections. It had formerly belonged to Eusebius Mandyczewski, who kept a cabinet with the collected edition of Beethoven's works, as it had been assembled by Archduke Rudolph, on one wall. On the other side of the room stood a cabinet containing the collected works of Johannes Brahms in their first editions, annotated with various corrections by Brahms himself. The unique feature of the room was its large window with a magnificent view of the majestic baroque Karlskirche, built by Fischer von Erlack. This view has been repeatedly drawn and painted by artists.

In one respect my new position was particularly beneficial to my health. In the army I had become quite a heavy smoker. On my first day at the Gesellschaft, I automatically pulled out my case to light a cigarette. Immediately the attendant came to me exclaiming, "Herr Doctor, you cannot smoke here. There is too great a fire hazard among all these dry old papers. However, it is perfectly all right to smoke in the entrance corridor downstairs." So I walked down three flights of stairs to the entrance, smoked my cigarette, and climbed up again to the top floor, for there was no elevator in the old building. The same procedure happened an hour later, but after a week or two I got tired of the repeated descents and ascents. I stopped smoking altogether, and have never resumed the habit.

Irene and I now worked in the same building, Irene as an

employee of Universal Edition on the second floor, and I as an employee of the Gesellschaft collections on the third floor. We decided that it would be advisable for us to live closer to work and to avoid the time-consuming commute by streetcar from the suburb where my parents lived to the center of town. We therefore started apartment hunting in the vicinity of the Musikverein. This was no easy task, as Austrian apartments were under rent control, a law very popular in Vienna where 90 percent of the population lived in rented apartments. It meant, however, that in a period of inflation and constant devaluation of the Austrian schilling, the landlords could not raise the rent, nor could they give notice to the tenants. Everybody sat tight in the place he occupied, and it was most difficult for newcomers like us to find suitable accommodations. At last my very skillful father discovered something suitable for us. It was a little apartment in the Ungargasse within walking distance of the Musikverein. A large old house, formerly occupied by a wealthy family, had been vacated through the death of the last owner. The new landlord had subdivided it into several small apartments. My father bought one of them for us at a very substantial price. This "purchase," however, did not mean that we owned the apartment, but only that we could enjoy the benefit of rent control, paying a nominal sum monthly and being secure from eviction. The policy of landlords demanding a high cash price for the very few apartments that came on the market was officially frowned upon but generally adopted while the authorities looked the other way.

Our new housing consisted of three large rooms. There was no bath, and the plumbing in the toilet was old and unsuitable. However, there was a big, dark storage room which we ourselves transformed into a kind of bathroom.

We remodeled the toilet completely, and Irene saw to it that the coal-burning kitchen stove was replaced by a gas range. The kitchen contained a huge chest, which was filled with coal weekly to satisfy the voracious appetite of the three big stoves of the apartment. (We were longingly thinking of the central heating my father had installed in our house in Sievering.) The kitchen also contained a large icebox that consumed a huge block of ice each week to maintain the necessary refrigeration for our perishable food.

We used the first of our three rooms as a living room with a dining area. The room also contained two large bookcases housing the scientific and literary publications Irene and I owned. A short corridor with our telephone led into a second room, which also served dual purposes. It was subdivided by a large cabinet as well as by curtains. The front part was our music room. There stood our piano and my violins, viola, and a large wooden music stand. The cabinet was filled with our music. Behind the curtain were our twin beds and two large closets for our clothes, linens, etc. The third room remained, at first at least, more or less unoccupied, as we reserved it for possible later occupancy if and when the size of our family increased. The apartment could have been quite pleasant, but it had one fault to which I never became accustomed. It was on the second floor of a busy street, and when we opened a window a fine layer of dust presently covered every object in the room. There was also constant noise from the street and, worst of all, we lived near a curve on the streetcar line. Whenever a streetcar passed, which happened every three minutes, the rails screamed in protest. Now, after more than fifty years, I still can hear this abominable screeching noise which tormented me during all my waking hours.

However, we had no choice but to accept these inconve-

niences. A tiny benefit of the apartment was the fact that across from us on the same corridor lived the celebrated actor, Hermann Thimig, the most famous member of a remarkable family of actors: the father, Hugo, the younger brother, Hans, and the sister, Helen, who was married to the renowned theater producer, Max Reinhardt. I frequently saw members of the clan, and we exchanged greetings and a few friendly words in passing each other.

The direction of my research changed radically during the first year of my work for the Gesellschaft. One day a gentleman, previously not known to me, appeared in my office and introduced himself as Ernst Bücken. The name was familiar to me, as he was a Professor of Musicology at the University of Cologne and had edited an extremely successful big handbook in ten volumes covering all fields of music-historical research. Outstanding scholars in Germany and Austria had contributed to this ambitious venture. Bücken now had a new idea; he planned to edit a twelve-volume set of musical biographies, each dedicated to another important composer. The series was to be started with a volume on Josef Haydn, since the year 1932, the bicentennial of Haydn's birth, was not far away. Bücken asked me whether I would be interested in writing such a biography for him. He had chosen me because I was in charge of one of the world's largest Haydn collections and had also acquired a modest reputation—though in a different field—as a budding scholar. I had never paid much attention to the Haydn holdings of the Gesellschaft, as I had done no Haydn research, but I was tempted by the offer and accepted Bücken's invitation with pleasure.

The contract, which I eventually concluded with the large publishing house, Athenaion, in Potsdam near Berlin, was dated October 3, 1930. It stipulated the exact length of

the forthcoming book: 96 large-scale pages of text, 25 pages of illustrations, and 39 pages of musical examples. The organization of the whole material was prescribed by Professor Bücken, the editor of the whole series. The complete manuscript, including the pictorial material and the musical examples, had to be delivered by me by September 15, 1931, so that the publication of the book in the course of 1932 would be possible. I was specifically warned to keep each part of the manuscript to the prescribed length, as the publisher planned to advertise the book long before it was available and didn't want to be forced to change the publicized price. The difficulties I faced were enormous. I had to write a book in a field heretofore almost completely unknown to me and to produce it with utmost speed. A large amount of preparatory spade work had to be done before I could start on the actual writing.

In the course of my research I was, however, pleasantly surprised to find that practically all the material necessary for the book was available in the Gesellschaft. C.F. Pohl, who had been the curator of the Society before Mandyczewski, had collected a gigantic amount of Haydn's music and biographical material as a basis for his own Haydn biography. He had been so conscientious in the preparatory work that he was unable to compete the biography. The first two volumes appeared in print in 1878, and the book was only competed by Hugo Botstiber long after Pohl's death. Thus I did not have to hunt laboriously in various libraries and archives for the material I needed, but found practically everything in our own collections. I got very little sleep during this eleven-month period, but I managed to deliver the completed manuscript, with its music examples and pictures, at the prescribed time. Several books on Haydn appeared in 1932, but I can safely say that my own book is the only one

of them which is still in print and in use. Its third revised and enlarged German edition was published as late as 1986 and by Wilhelm Goldmann Verlag in Munich and B. Schott's Söhne in Mainz, the third revised and enlarged English edition in 1982 by the University of California Press in Berkeley.

I still remember with amusement a little incident during the Haydn year. I frequently had an opportunity to show visitors some of the treasures of the Society's collections. Among the visitors were celebrities like Casals, Furtwängler, Toscanini, Pfitzner, Hindemith, and Rachmaninoff. Thus, one day I had the pleasure of guiding the distinguished English violinist and musicologist Marion Scott through our special Haydn exhibit. The lady showed the greatest interest and examined every item carefully. When she left she remarked casually, "I stepped into your office for a moment, Dr. Geiringer, and left something on your desk." "I am curious to see it," I responded, "and I must tell you also that I have something prepared for you," and I gave her an elegantly wrapped little package. It contained a piece of music I had recently received from the publisher, a Haydn String Quartet well known in the eighteenth century and acknowledged by Haydn but forgotten in later times; it was always excluded from the collected editions of Haydn's quartets in general use during the nineteenth and twentieth centuries. I had come across this attractive little composition through a casual remark by the great Schubert- and classical music-scholar, Otto Erich Deutsch. I decided to offer it to the publishing firm of Nagel in Hanover, who eagerly accepted it for publication. Much to my surprise, the present of Marion Scott contained exactly the same work! She had published the work through the Oxford University Press, neither of us knowing of the other's interest in this relic from the past.

The Haydn year 1932 was immediately followed by the Brahms year 1933, celebrating the centenary of the composer's birth. For this occasion Dr. Kraus and I prepared a special exhibit of the master's work. From our storage facilities we brought huge wooden boxes containing the master's extensive library, which the Society had inherited according to his bequest. It demonstrated the composer's wide interests. There were not only books on early and contemporary music, but also a substantial collection of music theory works from earlier centuries. Brahms's personal library contained books on fine arts and heavily annotated guide books with special emphasis on the treasures in Italian museums. There were quite a number of volumes of belletristic literature and numerous collections of poems. Brahms was a compulsive reader and he liked to single out phrases which he particularly liked, underlining sentences or marking them with a line in the margin of the page. If a paragraph particularly impressed him he wrote in the margin "n.b." (*nota bene*, note well). I amused myself by collecting some of these remarks, and they offered a vivid picture of the man's sharp and critical mind.

Brahms' personality was certainly full of contradictions. Throughout his life he complained that he had no fixed position and especially that his home town, Hamburg, did not appoint him as a conductor but, when he was invited to fill a permanent position as, for instance, Conductor of the Gesellschaft der Musikfreunde, he gave it up soon as too restrictive. Brahms was very susceptible to female beauty and charm, especially when it was connected with an attractive singing voice. He fell in love repeatedly, but always avoided a permanent liaison and remained a bachelor all his life. He was a very wealthy man, but was not in the least interested in financial matters. He readily gave his money away, and was

always casually—even sloppily—dressed. Apart from his magnificent library he had few personal possessions and lived permanently in a rented apartment with rented furniture. He ate very frugally in a modest Vienna restaurant, but was delighted when wealthy friends invited him to sumptuous dinners. Frau von Miller, to whose house Brahms was frequently invited for dinner, carefully kept a diary in which she entered the opulent menus offered to Brahms so as to avoid repeating the same dishes. Whenever the occasion arose Brahms was pleased to deviate from his spartan mode of life and to eat and drink quite heavily. The eventual cancer of the liver to which he succumbed may have been partially caused by such excesses.

I was indirectly allowed a glimpse of this ambivalent and fascinating personality through an unexpected discovery I made at the time. I found a large sealed package in a store-room on which was written "Not to be opened before 1927." This was, however, 1933, and without compunction I broke the seals. Before me I found a huge collection of letters addressed to Brahms and carefully preserved by him. There were primarily letters from members of the family, his mother and father, his brother and sister; but there were also letters of countless other persons, among them Brahms's teacher, Eduard Marxsen, and from composers d'Albert, Grieg, Liszt, Dvǒrák, and Richard Strauss. Brahms had also exchanged letters with the musicologist Sir George Grove, the Beethoven scholar Nottebohm, the Handel biograher Chrysander, with C.F. Pohl, and Eusebius Mandyczewski of the Musikfreunde. Even Richard Wagner's intimate friend, Mathilde Wesendonck, was represented by her letters.

Many of the writers had reclaimed their own letters after the composer's death, but a substantial number had been retained by the Society and they were stored with the under-

standing that the package was not to be opened until thirty years after the composer's death in 1897. There were no restrictions after 1927. With some difficulty I obtained permission from the Society to make use of this valuable material. Irene read all the letters and conceived the idea of using them as a basis for a complete life of the composer that she wrote. To it I added chapters on the master's work, profiting here, too, from the very rich possessions of the Gesellschaft. Thus we jointly produced a biography, with Irene largely responsible for the biographical section while I discussed the music. Owing to the fact that permission to use the material was given specifically to me, Irene's important collaboration was not mentioned at first. The small publishing firm of Rohrer in Vienna undertook the publication of our joint effort.

We were, however, particularly interested in obtaining an English-language edition of our work. A distant relative of mine living in London, a Mrs. H.B. Weiner, together with Mr. Bernard Miall, translated the book, and it was published by the distinguished firm of Allen and Unwin in London and simultaneously by Houghton, Mifflin in Boston, Massachusetts. This was the beginning of my very pleasant relationship with Allen and Unwin, which lasted for more than half a century while the leadership of this firm was successively held by three different presidents: Sir Stanley Unwin, Philip Unwin, and Rayner Unwin. This firm also secured publishers in various other countries which issued translations of our books.

In the following years I continued the exploration of the inexhaustible Haydn and Brahms materials in the Society. I also edited a number of works by earlier composers, which were published by Universal Edition. Moreover, Irene and I provided the biographical foundations for a large catalog of

instrumental music that a wealthy American music lover, Mr. Edwin Fleisher, had assembled and presented to the Philadelphia Public Library.

BEFORE reporting on our further fate, I would like to mention a few outstanding persons I met during the years I worked for the Society. There was, first of all, Pablo Casals, who came in 1933 to play chamber music during the Brahms festival arranged by the Gesellschaft der Musikfreunde. He was not only the greatest living cellist and a gifted amateur director, but also a charming man with a very friendly personality. He took immediate interest in the unknown compositions I was preparing for publication and made friendly and complimentary remarks about my two books, which he knew quite well. When he learned that I planned to emigrate to America, he sent me half a dozen recommendations to influential people in New York. (I still have these letters today, for I never found a suitable occasion to make use of them.) Decades later, when we were already firmly installed in the United States, Irene and I visited the maestro in Puerto Rico, where he had retired. Both he and his young wife received us most cordially.

Another participant in the Brahms celebration was the composer Paul Hindemith, who was also an accomplished viola player. I became acquainted with him during rehearsals I attended and found him to be a friendly, though somewhat stiff person. He, too, was very much interested in early music. He visited our archives and museum, and we had some pleasant exchanges of information about Renaissance compositions. In much later years in America I had occasion to arrange an exhibit of modern music. I wrote to Hindemith, who was at that time active as a professor at Yale University, and asked him for one of his autographs and a

photograph. He promptly answered that he had no picture brought from Europe, but he sent me the original manuscript of a curious duet for violoncello and bassoon in four movements. After our exhibit had closed I met Hindemith on a visit to New Haven and wanted to return the manuscript to him. "Don't you wish to keep it?" asked Hindemith, rather surprised. Of course I wanted it, and I still have it today. I found out that it was an unknown original composition of his and he had not even retained a copy. I have edited it and it was printed by his regular publisher, B. Schotts Söhne, in Mainz.

Another interesting visitor to our archives was the piano virtuoso and composer Sergei Rachmaninoff. I found him to be a very elegant man of the world who had mastered not only his native tongue of Russian, but who was also fluent in German, French, and English. I gave him a copy of my Brahms book, and he accepted it graciously. I received two notes from him during the following days. In one of them he thanked me again for the book, while in the second he pointed out a mistake in it. I had mentioned among Brahms's acquaintances the composer Arthur Rubinstein, whereas the person I was referring to was Anton Rubinstein. The mistake had really been caused in the publisher's editorial office. They did not like my abbreviating the composer's first name as "A" and substituted the full name of the famous living pianist for that of the long-dead Russian composer. This faulty change was made after I had seen the last proof.

I also briefly met Wilhelm Furtwängler, the director of our choral concerts. He was a tall, thin, very sensitive, and nervous man. Furtwängler was a wonderful conductor, and few other musicians have equaled his fine interpretations of the classical and romantic repertoire. It was amazing to notice that Furtwängler, who was a stickler for details, indi-

cated each separate quarter note while he conducted with the trembling point of his baton.

Likewise I had occasion to attend some wonderful performances of Italian operas by Maestro Arturo Toscanini. During our honeymoon Irene and I had the opportunity to hear an unforgettable *Don Carlos* by Verdi at La Scala theater in Milan. I also had occasion several times afterwards to attend highly inspired dramatic interpretations of Italian operas by the maestro. I was less impressed by his achievements as an orchestral conductor when he interpreted works by Austrian or German masters. His theatrical mannerisms during his rehearsals with the outstanding Viennese Philharmonic Orchestra also annoyed me. He staged outbreaks of uncontrolled fury if a passage did not sound to his liking, broke the baton, and threw his score to the floor. (He seemed to have brought it to the rehearsal just for this purpose, as he was far too nearsighted to consult the music while conducting.) Before a performance of Schubert's great C-Major Symphony, which was to take place in the Musikverein, the attendant suddenly came to me and said, "Please take the autographed score of the symphony (one of our most priceless possessions) immediately to the artist's room. Toscanini wishes to see it before he conducts it." I had to unlock the doors of the archives, get hold of the volume, and bring it to the maestro, who was waiting fully dressed for the concert. He looked at the score for a moment, reverently kissed it, and then said: "Now I am ready to conduct the symphony." Thereupon he stalked out to the platform and the concert began. I never knew afterwards whether I should be angry or amused by this little comedy.

The visitors to our museum included quite a few other personalities. Among them was the renowned pianist Wilhelm Backhaus, whose picture I took with my little cam-

era while he was leaning over my desk attentively examining a piece of manuscript. There was also the well-known conductor of the Vienna Opera, Felix Weingartner, who complained to me that the members of the strictly male orchestra didn't allow him to let his young wife, a former pupil of his, conduct opera performances. Weingartner also decided to complete the unfinished manuscript of Schubert's E-Major Symphony (not the famous B-Minor torso) which I showed him. His attempt at restoration of the fragment was, of course, quite unsuccessful. The hunchbacked composer Hans Pfitzner, author of the opera *Palestrina*, which was performed at the Vienna Opera, came likewise, complaining bitterly about the unfriendly attitude of some of his colleagues.

Ernst Křenek was another angered and frustrated musician with whom I became acquainted. His jazz opera *Jonny Spielt Auf* had achieved world success and had been performed in more than a hundred theaters. But his twelve-tone opera *Karl V,* written under the influence of Schoenberg's, Berg's, and Webern's music, met with strong resistance. It was accepted by the Wiener Staats-oper, but after the first rehearsals it was taken off the repertoire and a performance was no longer considered. I was to meet Křenek again half a century later, both in the U.S. and in Europe. By that time his reputation as one of the great composers of our time was generally acknowledged.

Irene also telephoned me occasionally if an important visitor came to Universal Edition, and I quickly dashed down the stairs to meet him. Thus I came in one day when Alban Berg majestically walked through the office with his beautiful wife on his arm. He had just finished the composition of his violin concerto commissioned by the American violinist Louis Krasner. For a long time he had postponed

work on this score, but then a tragic event inspired him to write a dramatic composition. The young Maron Gropius, a daughter of Gustav Mahler's former wife, Alma, had suddenly died of infantile paralysis. Thus he wrote his concerto *To the Memory of an Angel* and described in it, in highly dramatic terms, the life, death, and transfiguration of the child. The composition was enlivened by quotations of a Corinthian folk song and a chorale from a Bach cantata. Berg was now in a great hurry to see the new work in print. He implored Irene, who supervised the production, to hasten it, and for special emphasis he brought her a box of chocolates.

Berg was not fated to witness the first performance of his magnificent opus. The feverish work on the score had greatly weakened him. He died suddenly from blood poisoning contracted through the bite of an insect. He was only fifty years old and apparently at the peak of his creative abilities.

IN our personal life we also went through exciting experiences. At the beginning of our marriage we had never contemplated having children. Although Irene worked full time at the Universal Edition and I in the Gesellschaft, our financial circumstances were precarious. But, then, with the moral encouragement and financial support of my parents, we seriously considered having children. It took quite some time before Mother Nature cooperated. There were miscarriages before Irene at last got properly pregnant and everything seemed to be going smoothly. I went on an extended business trip for the Society, and while I was away a catastrophe happened. Irene stepped on some orange peel carelessly thrown into the street and fell heavily to the ground. A child was born prematurely, and though it was already perfectly formed, it was unable to live and died within a few hours.

When I came home everything was over and the little girl, whom I had never seen, was buried already.

For quite some time afterward Irene didn't want to make another attempt. Finally she was pregnant again and, to be quite on the safe side, she consulted Vienna's foremost gynecologist, Professor Halban. He examined her carefully and then told her that everything was in perfect order. "You do have," he uttered casually, "a little growth next to the embryo, but it doesn't seem to be malignant and we can easily remove it once the child is born." We were very pleased about the verdict, and Irene continued her work at Universal Edition without any break. On the 29th of January, 1936, while we attended an opera performance of Mozart's *Don Giovanni*, Irene remarked calmly, "I think my time has come. You'd better take me to Rudolfiner Haus after the opera." This was a fine hospital in a suburb. We went there by taxi and Irene quickly disappeared while I sat waiting during the rest of the night. On the morning of the 30th of January the obstetrician who had attended her came out of the delivery room smiling and exclaimed, "Congratulations, you have a baby boy!" We chatted for a while, but suddenly a nurse appeared and whispered something in the doctor's ear. I noticed that a red color slowly suffused his whole face and he dashed out after the nurse. A few minutes later he appeared again and said rather sheepishly: "Congratulations, you have a second boy!" The growth next to the embryo which Professor Halban had observed was actually a second child, and it was not noticed by the attending physician during the delivery of the first baby. We were now quite unexpectedly parents of twin boys. When I telephoned the news to my sister-in-law her reaction was the exclamation, "Are you crazy?"

My parents, who had greatly looked forward to the birth

of a grandchild, were not fated to witness the happy event. After we had moved out of the house in the suburbs they found it to be far too large for two old people, and had moved into a small apartment nearby, leaving the house itself unoccupied. My father, who had been suffering from angina for quite some time, passed away in 1932. He was in his early seventies. My mother, who was nine years his junior, was unable to live alone after their long and happy marriage. She followed him in death only two years later. It took both Irene and me a long time to get over these losses, especially since Irene's father had also died a few years earlier.

The first boy, whom we called Martin after my mother, Martha, was strong and healthy, but Ludwig, named after my father (in later years he preferred to use his second name, George) was underweight and extremely delicate. He was immediately put into an incubator and whisked into a children's hospital. However, he needed mother's milk, which created a problem as Irene had returned to her regular work soon after the birth of the children. Thus she was forced to pump milk regularly, which was then quickly transported to the child. This was painful and very tiring for poor Irene, but, with her usual tenacity, she did double duty as a nursing mother and a competent office worker.

I remember an early visit I made to the hospital, where I was allowed to see the baby in the incubator. This was a wooden box with a glass cover, warmed by an electric light bulb. All I could see was a tiny body with actively moving arms and legs; but there was no head. As I found out later, the head was left outside the box so that the baby could breathe fresh air. At that time, however, I assumed that newborn babies had no head yet and that it developed only at a later time.

After several weeks the baby was finally allowed to come

home, and he came with a nurse who had taken care of him in the hospital and fallen in love with the tiny boy. Henceforth "Tetta," as all of us called her, took care of both children, sleeping in the same room and attending meticulously to all their needs. She remained with us until we left Vienna permanently. All of us—the children and Irene and I—were sad about the separation.

Emigration

OUR DEPARTURE from Vienna was caused by the political development in Austria. After the end of the First World War, the Austro-Hungarian Empire was fragmented by the Allies. Parts of it were assigned to Italy, others to Yugoslavia, Romania, and the reconstructed Poland. The rest was further divided into three small and ineffectual countries: Austria, Czechoslovakia, and Hungary. Austria itself was politically divided between conservatives and radical socialists. There were open fights in Vienna, which were brutally suppressed by the reactionary Prime Minister Seipel, who had soldiers shoot cannons at the blocks of houses in which socialist workers defended themselves.

In the following years an uneasy calm prevailed, but mounting pressure came across the border from Germany. There the National Socialists had gradually entrenched themselves and were greedily attempting to extend their domination also over Austria. For a while Mussolini, who was not anxious to see Germany at Italy's border, protected

the small Austrian state, but it was not enough. The Austrian prime minister, Dollfuss, was murdered in his office by a group of German National Socialists.` His successor, Schuschnigg, valiantly tried to stem the avalanche. He visited Hitler in Berchtesgarten and called afterwards for a plebiscite in Austria to decide whether the people wanted Austria to be united with Germany. Hitler didn't wait for the outcome of this test. During the night of the 12th of March, 1938, he crossed the border at the head of the German army.

When I arrived at the Musikfreunde on the morning of the 13th I found a German SS man blocking the entrance to the building. The Society had been closed by the Nazis and its officers dismissed. At a later date some selected persons were reinstated, but the majority had permanently lost their positions. Among them were the president of the Society, Prinze Thurn-Taxis, one of Austria's oldest aristocrats; the prime minister of Austria, Schuschnigg; Herr Anthony van Hoboken, a wealthy Dutch music lover and owner of the world's largest collection of musical first editions (which he had prudently removed to Switzerland a few weeks earlier); the Jewish bank director Wilhelm Kux; and finally, I myself. I was a Roman Catholic and had seen to it that my children were baptized a few days after birth, but my parents had been Jewish and thus in the eyes of the Nazis, I was a Jew too.

On the first morning of the regime I heard great shouts of jubilation from the neighboring thoroughfare of the Ringstrasse. I went there and saw German troops marching by, followed by a row of automobiles. In one of them, an open car, Hitler himself stood upright, happily giving the Nazi salute of the upraised arm while the crowd, frantic with joy, exclaimed, "Heil Hitler! Heil Hitler!"

During the next days it seemed that in Austria there were

only two groups of people; the ardent admirers of the Nazi movement, and, on the other hand, a small minority of well-known socialists and Jews, blacklisted by Hitler, the man now in power.

I was horrified by the situation, and Irene, although she continued her full-time work at Universal Edition, shared my feelings. Against the strong advice of friends and relatives, we decided to emigrate from Austria. My brother Ernest (who, himself, was already residing outside of Austria) warned me against leaving. "You will never have as good a life as you have now," he said. Our resolve did not change, however. At the first possible moment I went to the American embassy and applied for immigration visas to the United States for the four of us. At the embassy, however, I had quite a bad shock. America had a quota system for immigrants, and because one of my ancestors had lived in a Bohemian city of the Austro-Hungarian Empire, I was now considered to be a Czechoslovakian. The quota of immigrants from that country was very small, and I would have to wait many months before our turn came. I left my name on the list of applicants anyway, but decided after brief deliberation to try my luck at the British Embassy. There the reception was quite different. The ambassador himself found time to see me. He knew of my English book and of some work which I had previously done for the BBC, the British Broadcasting Corporation. When I showed him pictures of my sons he exclaimed, "These children must get out of the country!" Without further formalities I received visitors' visas for England.

A few hectic weeks of preparation for departure now followed. We decided to have our furniture and books put into storage, as we wanted to travel as lightly as possible, with only luggage which we could carry ourselves. We were not

allowed to take any money or jewelry of value out of the country. Numerous formalities had to be completed before we obtained valid passports, but there was no basic objection against our leaving the country. The hermetic sealing of the border came only at a later time. We gave away all our savings and even some of the few pieces of jewelry Irene and I had inherited. We were, of course, allowed to buy our own tickets for the trip and, as our money had no value for us anymore, we purchased first-class tickets and sleeper accommodations on Europe's most luxurious train, the Orient Express. Before we left, however, our hand luggage had to be inspected by a Nazi officer to ascertain that we took no money or valuables out of the country.

We announced our intention to emigrate to the authorities and daily expected the arrival of an inspector. Nobody came, however, and we were frantic as the day of departure came closer and we knew that train reservations for a specific date could not be changed. A friend of ours, who was a good Nazi himself, laughed when he told him of our fears and said, "Go to the British travel bureau of Thomas Cook and Sons and they will take care of your problem." We followed his advice and the man in the travel bureau was not particularly surprised. He asked me to pay a sizable part of my meager financial resources, and said, "Matters will be all right." The next morning an SS man, in full uniform, appeared in our apartment and demanded curtly, "Where's your luggage?" He did not ask us to open any piece and quickly sealed each suitcase. In less than five minutes he had left us again. I never found out how the money I had paid to Thomas Cook had come into the right hands.

I had not been totally unprepared for a major move out of Austria. For years I had tried to cultivate relations with foreign countries. I regularly sent reports about the musical

life in Vienna to the French periodical, *La Revue Musicale*. Some articles of mine had appeared in English and American periodicals, and the BBC frequently aired programs of rarely heard music chosen by me and accompanied by my comments. There was also my Brahms book published in England and America, and the leading American publisher, G. Schirmer in New York, had commissioned me to select and edit twenty pieces of choral music for their publications. In previous years I had also traveled twice to London to negotiate with the British Museum for the sale of duplicates from the Gesellschaft der Musikfreunde's large holdings in first editions of music by the great classical composers.

A few weeks before our departure an aristocratic young English lady, Miss Bonham-Carter, had also visited our collections. When she was ready to return to England I asked her to write to the various publishers and to the BBC on my behalf, asking them not to make any payments to me until I asked specifically for them. I did not dare to write these letters myself, as censorship of the mail had been ordered by the authorities. On the other hand, I wanted to be sure to have a little money waiting for me upon arrival in a foreign land, since I was not allowed to take more than a few schillings out of Austria.

The day of our departure finally arrived and, accompanied by a large convoy of friends, relatives, and our maids, of course, we went to the West-Bahnhof. There we had a shock. It was discovered that in the general commotion the special food for our children, who had very delicate stomachs, had been forgotten at home. This was practically the only time I saw Irene cry uncontrollably.

Our long train ride to Paris, and from there to Calais, turned out, however, to be quite pleasant. We enjoyed the

luxurious accommodations and found our food in the dining car, which we had prepaid in Vienna, very tasty. Somehow Irene also managed to provide some dishes acceptable to the children.

In England

In Calais we took the boat to England. It was a large, roomy, and comfortable ship. We looked after our luggage and then found a good place on deck protected from the sharp breeze. But then we suddenly discovered that the children had disappeared. We looked all over the boat, which had in the meantime left the harbor, but could not find them. The boys were very fast on their feet and often ran away, but this was certainly the worst situation of its kind. Finally a friendly sailor, who noticed our frantic search, told us, "If you are looking for two little boys, they are quite deep down in the ship looking at the engines." And there we finally found them. They were watching the motion of the giant wheels with fascination. No further mishaps occurred during the passage, and we arrived in Dover harbor happy, though very tired, and without a penny. The very little cash we had been allowed to take out of the country had been spent during the trip to buy food for the children.

Fortunately the husband of the charming young musician with whom we had been on very cordial terms while she studied in Vienna, met us at the dock. With this girl, a very talented pianist and composer, we had had some quite amusing experiences back in Austria. Her German was not good, and she said to the porter in the hotel one evening: "*Waschen Sie mich bitte um sechs Uhr*" (please wash me at six o'clock). She meant, of course, "*Wecken Sie mich bitte um sechs Uhr*"

(please wake me at six o'clock). To Irene she complained: *"Ihr Gatte zieht mich immer aus"* (your husand always undresses me). What she meant was, of course, *"Ihr Gatte zieht mich immer auf"* (your husband always makes fun of me). She did not realize, of course, what a difference in meaning the change of one letter produced. She accompanied us once on a mountain hike near Vienna and caused a sensation. Helen was not used to heavy shoes and found her newly bought mountain boots unbearable. She took them off in the middle of the trail and preferred to walk the rest of the time in her stocking feet over the sharp rocks.

Mr. Adie, whom Helen had recently married, proved to be a very friendly man and amused the children in a most charming manner during the railroad trip to London. He set us up in a modest little apartment in a London suburb, and we began our new life with curiosity, mixed with apprehension. My main problem was to find work to be able to support the family; but first of all I had to acquire a work permit from the authorities. In this situation my brother Ernest came to the rescue. Since I had last seen him, his employer and he had determined that Czechoslovakia was not the safest place to stay, and they had moved to some remote place in the English countryside. When Ernest learned of my problem he persuaded Mr. Weinmann, who was an extremely rich man, to put forty thousand English pounds into my account at Barclay's Bank. This was a gigantic sum at that time, and when I went with the receipt of the bank to the home office the authorities were very impressed. They had the assurance that I would not require financial support and thus they gave me the necessary working permit without hesitation. Presently the forty thousand English pounds disappeared from my account, but I was now able to earn some money.

To find work was not quite as difficult as I had feared. The BBC and its director, Sir Adrian Boult, immediately accepted some interesting scores for performance, which I had brought from Vienna, and commissioned me also to provide the necessary verbal commentary which the announcer could read. Mr. H.C. Colles, the music editor of the *Times*, had learned of our difficulties and was most helpful. He was in the process of preparing a new edition of Grove's famous *Dictionary of Music and Musicians* for the McMillan Company. Contemporary Austrian and German composers, performers, and musicologists were hardly represented at all in the early edition, and he asked me to remedy this situation. Thus I gradually wrote close to one hundred articles for the new book and received quite good pay for it. The necessary material for these brief essays I acquired largely by letters I wrote to the persons in question. Their revealing answers have, in most cases, still been kept by me, so that I gradually acquired quite an interesting little collection of autographs.

Colles also recommended me to the director of the Royal College of Music, Dr. George Dyson. When I went to see him, a rather funny little incident happened to me. Irene had carefully cleaned and pressed my suit so that I would look respectable at this important visit. I had to wait in the room of the secretary while Dr. Dyson was engaged in a prolonged telephone call. As was customary in England, the room was icy cold, and only a small electric heater on one side of the office provided an illusion of warmth. I moved closer and closer to this heater while watching the secretary's busywork. At last Dyson finished his conversation and I entered his office to see him. He was quite cordial and asked me to take care of the college's small but very valuable collection of musical instruments from the Renaissance and baroque periods. I was also to offer occasional lectures on these instru-

ments to the students. After I had shaken hands and was walking out of the office, I heard Dr. Dyson giggling a little bit behind my back. I turned around and asked with surprise, "Is there anything wrong?" Thereupon he broke into loud guffaws and exclaimed, "Look at your trousers!" Only then did I notice an unpleasant coolness at the calves of my legs. As I had stood so very close to the electric heater in the anteroom, the sharp creases in my trousers had been burned through, and my calves were partly exposed.

Later I had also other comical—though fortunately not so unpleasant—experiences at the College of Music. It was the custom that students, faculty, and staff of the school took their noon meals together in a huge dining hall. Once a week the composer Ralph Vaughan Williams, who taught one or two classes at the College, joined us there. On these occasions the same thing regularly happened. The loud buzzing sound of countless conversations at the different tables gradually died down, and at the end only the booming voice of Vaughan Williams could be heard as he told one of his amusing risque stories. One night Irene and I attended the hundredth performance of his popular "ballad opera," *Hugh the Drover.* During the performance of the first act we were constantly disturbed by the laughter and loud noise made by a group of old men who were sitting in the last row of the balcony. During the intermission I went to the usher and asked her indignantly, "Couldn't you tell those gentlemen to be quiet during the performance?" She was quite horrified by the request. "I could not do that, sir," she explained. "That is Mr. Vaughan Williams with his old school friends." During the second intermission we were pacified when the ushers went around offering soft drinks and cookies to the whole audience "with the compliments of Mr. Vaughan Williams."

Our new life in England proved to be quite pleasant. We stayed in the country at first, not far from the sea, which was healthy for the children and cheaper than an apartment in London. I commuted, whenever it was necessary, by a fast train to London and took the underground to the Royal College of Music. My freelance work for BBC and for the dictionary could be done at home. We had, however, another hair-raising experience with the little boys. Irene had engaged a young girl to take the children to the beach while she herself attended to some household tasks. As we found out later, the girl had fallen asleep in the warm spring sunshine, and when she woke up the children were not there. She looked everywhere, but could not find them. So she ran crying to our house to bring us the bad news, confessing her negligence. In the meantime it had grown dark and the tide had come in, covering most of the sand on which the boys had been playing. We were especially afraid that they might have been playing under the pier, a place they particularly liked because it was protected from the strong sun, and it was now under water. We notified neighbors and the police, but finally had to give up the search because of the complete darkness. We didn't get any sleep that night. Fortunately, early in the morning a police officer called and told us brashly, "Two little boys have been brought in. If they are yours, come and collect them." We dashed over and found them hale and hearty, though yelling their heads off. They were still wearing only their bathing trunks and some friendly policeman had wrapped them in horse blankets. There were fleas in the blankets, which were biting them piteously. We never found out who the friendly soul was who had found the boys on the beach and taken them to his home for the night.

When it grew cold and unpleasant in the country we

moved close to London, settling down finally in a pleasant little home facing the common at Wimbledon. We occupied half of a small duplex building with a tiny enclosed yard in which vegetables and flowers were growing. In the other half of the building an old, retired gentleman and his house-keeper lived. We quickly established friendly relations with both of them, which proved in many respects to be benefi-cial. When Irene and I wanted to go out in the evening we needed no babysitter. The wall separating the two sides of the house was quite thin, and the old lady assured us that she would come over immediately if she heard the boys crying at night. All we had to do was to give her a key to our apart-ment so that she could enter. From one of the windows on the upper floor of her own apartment the housekeeper could also watch the activities of the boys frolicking in the yard. One day she unexpectedly arrived at our door and told Irene, who was working with me: "Forgive me, madam, for disturbing you, but I thought you ought to know that the children seem to be playing with a dead rat." We dashed out and found this to be correct. It took quite some time to scrub them properly so as to be sure that they had not been infected by the animal, which had obviously died quite some time ago.

Much earlier than we expected, we were notified that our American visa had arrived and could be collected at the con-sulate. By that time we were pleasantly installed in England and didn't want to move again. On the other hand, we could not afford to lose the chance to move away from Europe. Thus we asked for and received an extension of the validity of our visas for the maximum period of three months. When the three months were over, our situation had not changed and we asked for and received a new extension. However, we were warned that we could not continue this game; we

would have to make use of the visas or lose our chance to immigrate to the States. After long deliberation I decided on a kind of compromise: I, alone, would travel to the States and take the necessary steps to make a future move to America for all four of us possible. At the first opportunity I would then return to England. And this I did.

I traveled by boat to New York and found the big city quite intimidating. Carl Engel, the president of the Schirmer Company, for which I had previously done some work, received me quite cordially. He arranged for me to offer a lecture on Haydn's operas at a meeting of a learned society. Before the lecture he took me to his home for dinner and offered me some delicious cocktails which I had never tasted before. The result was that my tongue was quite heavy and my English even worse than it usually was. Accordingly the lecture was anything but a success.

I stayed in New York at the home of one of Irene's former colleagues from school. Her husband had been an attorney in Vienna, and foreign attorneys had to go through grueling examinations before they were allowed to practice in the United States. The family was without proper income while he prepared himself for his work in the new country. The atmosphere in the little household was very depressed, and I did not feel happy either. As quickly as I could I obtained my first papers of naturalization. On the basis of this treasured document I received a re-entry permit to the U.S. which would enable me to also bring my wife and children with me. It was valid for a lengthy period, and thus we were not forced to make an immediate decision.

As I had very little money, I wanted to make the return trip in the cheapest possible manner. My new friends found me a berth on a freighter which went from Boston straight to London. It was a tiny boat of not more than a thousand

tons and took only two or three passengers on each trip. Unexpectedly, the crossing, which took well over two weeks, proved to be very agreeable and relaxing. The weather was good. I had a large stateroom on deck for sole occupancy, and the food at the captain's table was excellent. The tiny ship could sail right up the Thames River and deposited me not too far from our little apartment.

However, the political horizon had begun to darken ominously. Hitler, after "liberating" Austria, had found that he must perform the same service for the Germans in Czechoslovakia. He first annexed the part of the country nearest to Germany and, before long, the rest of the powerless little nation. Neville Chamberlain, the English prime minister, traveled to Munich and Berchtesgarten three times, finally receiving assurance from the Führer that he would take no further aggressive steps. Chamberlain returned triumphantly to England with the message that "peace in our time was assured." There were, however, growing signs that Germany was preparing new adventures. Hitler had concluded a non-aggression pact with Stalin, and the German army seemed to be growing in size. On this basis, England and France had no choice but to prepare their own armies. When Germany attacked Poland in September 1939, war was declared. Chamberlain, who was an ill and broken man, resigned, and Winston Churchill, previously a member of Chamberlain's cabinet, became prime minister. A year of "phony war" followed. England prepared feverishly for the fight, but for a long time nothing seemed to happen. Gas masks were issued to every person in England, as it was feared the Germans might attack with poison gases, which they had used with devastating effect during the First World War. Whenever we went into the street we had to carry our masks in a container with us.

During the long period of uneasy expectations in which nothing happened, the nervousness of the population increased. Suddenly the authorities decided to do something that would show that they were on the job. They rounded up all "enemy aliens" and took them to the Isle of Man, a small, inhospitable island off the coast. These "enemy aliens" included the refugees from Germany and Austria. The deportation was greatly feared, as it was known that the accommodations on the island were bad and the food insufficient.

The English authorities preceded methodically to round up aliens in alphabetical order. When they reached the letter *F* I decided to leave everything behind and to take my family to the United States. During the night preceding our departure, the long-expected first air raid by the Germans on England took place.

America

W E SAILED on a rather old but still serviceable Cunard liner. Both a military plane and a battleship escorted us for protection at the beginning of the trip. The plane returned first, and when we reached the open sea the cruiser left us also. Our captain had been told that he ought to sail as fast as possible, thus making it impossible for the slow-moving German U-boats to attack us. Nevertheless, he took no chances. We were all provided with life jackets and instructed to always keep them by our side. At night we were not allowed to undress properly and had to wear the jackets even while sleeping. Once we were even awakened in the middle of the night for a drill, for the captain wanted to test our preparedness. Irene, the two boys, and I occupied a small, windowless, and not very well-ventilated cabin in the interior of the ship. Nevertheless, we found this crossing of the ocean quite pleasant and relaxing. It was certainly far better than what we met upon our arrival in the United States.

At first everything went quite well. There was no prob-

lem at immigration, and some photographers took pictures of our little boys, who were quite handsome with their long, blonde hair. Next morning these pictures appeared in the Sunday supplement of the *New York Times* and in *Life* magazine over the heading, ENGLISH REFUGEE CHILDREN.

The following days, however, were a real ordeal. This was the month of August and it was extremely hot in New York. We had practically no money left, since the crossing on the boat had taken all the small savings I had been able to accumulate during our stay in England. We rented a very cheap room in upper Manhattan. It was noisy, dusty, and uncomfortable. On the second day of our stay, the little boys, heated from play in the sun, greedily drank some ice water, which they were not used to, and presently they both contracted pneumonia. Our situation seemed desperate when an "angel" arrived and saved us.

I had met Berrian Shute years ago in Vienna, where he pursued his musical studies. He was a man of approximately my age. We liked each other and exchanged letters after his return to the United States. I had notified him of our arrival in New York, and he came to see us. When he realized our predicament, he immediately offered his help. He invited the four of us to ride with him in his car to the little village of Clinton, near Utica in upstate New York, where he lived with his family. He was currently a professor of music at the small Hamilton College situated nearby. In Clinton he found a tiny caretaker's house for us in a huge park belonging to the estate of a rich family living in New York City. There he helped us to get settled, and in the good clean air the boys quickly recovered from their illness.

Berrian did even more for us. He drummed up a nonexistent position for me in his music department starting in September. I had two pupils, to whom I was supposed to

teach music harmony, and I received the princely remuneration of one thousand dollars for the whole school year. Another thousand came from the American Philosophical Society in Philadelphia for a research project I was engaged in at this time. With these two thousand dollars the four of us managed quite well during the ensuing months. People in Clinton were nice to us, and we enjoyed the friendly atmosphere.

In particular, Irene and I liked to visit the house of Edward Root, a relative of Elihu Root, who served in the cabinet of Theodore Roosevelt. Edward was a wealthy art collector, very hospitable, and we were on most friendly terms with him and his family. On Christmas Eve he prepared a pleasant surprise for us. The boys were already asleep and we were reading when we heard a little noise outside our front door. We looked out of the window and saw Edward's son in the moonlight, creeping through the snow and pushing a little sleigh in front of him. This sleigh was just the perfect size for two little boys, and it was loaded with toys and various goodies for the four of us. All this was deposited at our front door, and the young man left quickly without ringing the bell. It was his intention, of course, that we should find it only on Christmas morning.

During the school year of 1940–41 I tried, of course, to obtain a permanent position. I would have liked to work again in a musical library, for which I was best qualified by my former work in Vienna. However, no suitable opening seemed to be anywhere. I also gave lectures in various places at scholarly meetings so as to gain a little recognition.

Fortunately, I also had a wealthy protector whom I had never seen but who, nevertheless, was willing to assist me. He was a philanthropist and had assumed the responsibility for a dozen refugees like myself, so that there was no danger

that they would become public charges. This kind man conceived the idea of sending letters to every president of a college or university in the United States, telling them that a great scholar had arrived from Europe and was available for a position in their music department. The result of this mighty action was zero. Most letters were never answered and the few presidents who bothered to respond only wrote they were sorry there was no opening on their faculty, but they would keep my application in an active file. (Irene and I afterwards always called our wastebasket the "active file.")

One morning, however, I found two letters in our mailbox, both from Boston University. One, from the president, expressed the usual regrets: "unfortunately there is no opening on the faculty." The second letter was from the dean of the College of Music and stated just the opposite. There was an opening among the faculty, and he, who had attended one of my lectures during a meeting in Cleveland, wanted to interview me. If I was interested, the university would pay my trip to Boston so that we could have further talks about the matter. I eagerly accepted the invitation, and Dean Meyer and I both liked each other. In view of my age and the previous publications of my Haydn and Brahms books and some English articles, I was appointed to full professorship and started work in the school year 1941–42. My salary was only $3,000, but I could also teach a couple of extension courses and was promised additional well-paid work in summer school. Thus a modest existence for the four of us was possible, and we moved to Boston.

Boston University

On the first day of school, Dean Meyer simply took me into a classroom where I found about forty students gazing curiously at me. I was terribly frightened, as I had hardly any experience in teaching a large class of youngsters. However, I had no alternative but to go ahead, and gradually I gained some confidence when I saw that the students were eagerly taking notes.

I had to teach different courses in medieval and Renaissance music, music of the classical and romantic period, and contemporary music. In addition, counterpoint and composition classes were also my responsibility. I was completely unsuited to teach composition, as I was no composer myself and had no idea how this art could be taught. But with the help of an excellent textbook by Percy Goetschius, I somehow managed to direct the work of my pupils. Fortunately, after a year, Hugo Norden was engaged and relieved me of my duties in the field of counterpoint and composition so that I could concentrate on teaching music history. Hugo Norden was joined on the faculty of the theory department by the composer Gardner Read. Unfortunately, the two men didn't get along too well. The conservative counterpoint wizard, Norden, and the progressive composer, Read, had rather different ideas of how the studies should be taught. I liked both men, and intervened several times to avoid serious rifts. Eventually I also received a helper in my own department. The younger John Hasson, who was partially my own pupil, relieved me of some of my duties by taking over the teaching of medieval and Renaissance music. Baroque, classical, romantic, and modern music remained in my hands.

In teaching these subjects I primarily pursued three

goals. I found that most of my students knew only the litera-
ture of their own instrument and were sadly ignorant of the
enormous range of significant compositions for other media.
When I had been a teenager, and later as a student at the
university, I went to concerts or to the opera daily, as I never
could hear enough live music. This attitude did not seem to
exist in Boston. The students rarely went to concerts, and
then only when the personalities of the performers were of
interest to them. In order to remedy this situation to some
extent I established long listening lists, requiring the stu-
dents to use our well-stocked collection of recordings. At
test time I frequently played records, asking students to
identify the piece and to comment on the music. In my
teaching I also reduced to a minimum the use of names,
dates, and life stories of composers, while emphasizing, on
the other hand, stylistic trends and the analysis of harmonic,
contrapuntal, and instrumental features. My classes were
accordingly called "History and Analysis." For three full
years the music majors had to take these courses. I started
the sophomores, who had already acquired a theoretical
background in their freshman year, with the discussion of
baroque and classical music. Hasson dealt with the medieval
and Renaissance music during the students' junior years, and
I finally introduced the senior students to romantic and con-
temporary music.

A further goal of mine was to make the students listen to
music not only with their ears, but also with their eyes. I had
all the scores we discussed in class photographed on film-
strips to project onto a screen during the lectures. This
made it easy to point out remarkable technical details. It
seemed to me that this visual instruction was of great impor-
tance for budding musicians.

I also started a Collegium Musicum in the department, in

which we performed mainly Renaissance and baroque music. We rarely used modern printed editions. I led the students to the original manuscripts and old prints, which we found in the excellent neighboring Boston Public Library. They had to produce their own performance materials from the original sources. I thought that this method would give them a much better understanding of earlier music than if they used modern transcriptions and arrangements.

When I had joined the music faculty, the college offered only the baccalaureate degree. The gradual enlargement of our own department and the general growth of the university enabled me to also introduce the master's and, finally, the doctoral degrees, thus attracting more ambitious and mature students. For them, Hasson and I offered advanced seminars pinpointing remarkable details in certain phases of earlier music.

I also introduced a weekly series of lectures on musical topics that was open to the public and free of charge. For a while I held them myself in the Boston Public Library, but then I transferred them to the university and invited lecturers from outside. Although we did not pay them anything—at best a nominal fee—we had no difficulty in attracting excellent speakers. The lectures were quite informative, and the docents could choose their own topics, sometimes even at the last minute. They were sure to find a receptive and friendly audience. Usually we did not even announce in advance the name of the speaker and the subject he had chosen to discuss. There were simply two chairs on the platform of our little lecture hall, one for the speaker of the evening, the other for myself so that I could introduce the docent and direct an occasional question and discussion period after the lecture.

I remember that I once found myself in a rather difficult

position. A speaker had been forced to cancel his engagement at the last minute, when the audience had already begun to fill the room. The traditional two chairs stood on the platform. I had to deal with the situation somehow, so I had no choice but to ascend the platform and say something to the expectant listeners. I sat down and began the traditional introduction of the speaker. I mentioned his career and outlined his scientific work without mentioning his name. It slowly dawned, first on my colleagues and then on other members of the audience, whose personality I was describing even before I ended my little speech with a flourish: "Thus, ladies and gentlemen, I have the pleasure of introducing to you tonight's speaker, Dr. Karl Geiringer." I arose from my seat, took the second, hitherto empty chair, and began a lecture improvised on the spur of the moment. I never had as much applause for a lecture as I had on that evening.

In addition to teaching I had also certain administrative duties at Boston University. I was not only in charge of the music history program, but also had to supervise theory and composition. Moreover, the graduate studies program was "headed" by me. I enjoyed thus shouldering greater responsibilities, although I took care at the same time that they would not take up too much of my time.

When I started work at Boston University, the College of Music occupied an old building next to the Boston Public Library. The building, which had formally belonged to an athletic club, was quite narrow, and our classroom and offices had to be placed on different floors. The students lined up in front of the small elevator to reach classes and practice rooms on various levels. I preferred to use the stairway, preaching unsuccessfully that regularly climbing stairs was beneficial to the heart.

The former athletic club had numerous washrooms and toilets but not enough office space. Thus I twice received nice accommodations in spaces which had formerly served as ladies' rooms. In both cases I immediately asked to have a little glass window put into the door of my office so that the interior of the room was visible from the corridor. I had been warned by the sad fate of one of my colleagues, who was dismissed from Wellesley College for supposedly forcing his attention on a woman student who was consulting him in his office. The window in the door assured me that everything happening in my office could be seen from the corridor.

After a few years of my work at Boston University, the college had to vacate the old building on Blagden Street, as the old house was to be torn down and the space used for an expansion of the public library. We moved into much larger quarters on Commonwealth Avenue. We shared this large building with the art and opera departments. All three were now incorporated into a larger School of Fine and Applied Arts under a newly appointed dean. Although I now had a much better and friendlier office, I missed the comfortable old quarters we had before.

I had to serve under four different deans who succeeded each other rather quickly, and there were many changes of policy. It was not always quite easy to adapt to different leadership. I handled these problems as well as I could and gradually established very friendly relations with members of the faculty both inside and outside my own little department. Thus Irene and I frequently visited the family of Professor Houghton, who taught voice and choral conducting. We were also on very friendly terms with the dean of Boston University's Methodist School of Theology, who lived not far from us. Dr. Walter Milder, his wife, and charming

daughters became good friends of our family, and we kept in contact with them even after we had left Boston University.

Particularly pleasant were my relations with the president of the University, Dr. Harold C. Case and his wife. He was a Methodist minister who had come to Boston from California and brought some faculty members from the West to our school. Dr. Case was very religious, but also a liberal thinker, and was conversant with many subjects outside his own field. Irene and I greatly enjoyed the company of this fine couple, especially since they were great music lovers. Dr. Case frequently invited my Collegium Musicum and me to his spacious home, where we performed selected numbers of our program to a small but very receptive audience. When I once mentioned Irene's and my wish to spend the summer in the mountains of Colorado, he generously offered us the use of the little chalet he owned near Denver. The house was very primitive, and there was no water, gas, or electricity. We had to use candles and oil lamps to light the rooms, and all the water we needed had to be brought from a nearby brook. Nevertheless, we spent a glorious summer there, which was greatly enjoyed by Irene and me and also by the little boys, who were passionate hikers.

On my fiftieth birthday, a surprise party was arranged at the president's home in Boston. He had invited not only colleagues of mine, but also some personal friends as well as some students. We were serenaded with little compositions written for the occasion by Norden and Read; and for once at this strictly dry university, wine was served with our pleasant meal. (Usually at parties Dr. Case accepted the glass offered to him but never drank from it.)

I also established very interesting though never close contacts with Sarah Caldwell, who was a highly admired but also controversial member of the faculty. She was in charge

of our opera department and entertained progressive and rather revolutionary ideas. Her programs were always very interesting, but she pursued her goals with a certain ruthlessness, stepping without hesitation on people's toes. With very limited means and in a small and primitive theater belonging to the University, she managed to put on remarkable performances of such challenging works as Verdi's *Falstaff*, Stravinsky's *The Rake's Progress* (inspired by a Hogarth engraving), and Hindemith's *Mathias the Painter* (dealing with the life story of the great German Renaissance artist, Mathias Grünewald).

I had an opportunity to attend the rehearsals for *The Rake's Progress* and was amused by Stravinsky's insistence on conducting this comparatively melodic opera with sharp rhythmic accentuation. He constantly clapped his hands, even during lyrical episodes, to clarify his intentions to the orchestra.

Among the visitors to the university was Aaron Copeland. He gave a concert of his own works, and I was very impressed by his display of technical skill in the performance of his technically quite difficult atonal piano variations. He told me afterwards during a pleasant conversation that this was an early work and his style of composition had greatly changed since he wrote it.

I met Albert Schweitzer, the great virtuoso, scholar, and philanthropist, who gave a lecture at our school at Boston University. We wanted, of course, to hear him play also, and, rather reluctantly, he acceded to our request. He played some Bach preludes and fugues on the organ of nearby Trinity Church with rather stiff fingers, but, nevertheless, quite beautifully.

During the years I taught in Boston we lived in three different locations. At first we were tenants in a cozy little

apartment in Newtonville. I walked to the railroad station and took a train to Back Bay Station in Boston, which was very close to the music building.

During this period a momentous event occurred that shook the very foundation of all our lives. On December 7, 1941, as we were giving a little afternoon party for some friends, my nephew, Frank Gardiner, burst into the room exclaiming, "What do you think about Pearl Harbor?" We didn't know what he meant, but he quickly explained that he had just heard the terrible news of the Japanese air raid over the radio. We were all speechless, and the guests quickly left.

Personally, I feared that the fate which I had barely missed in Europe would now overtake me. At the outbreak of the war in Europe, when internment of "enemy aliens" had started in England, I had immediately gone to the Czech consulate and asked for permission to acquire Czech citizenship, basing my request on the nationality of some of my ancestors. The authorities were inclined to accede to my request, but told me that I would have to join the Czech resistance army, which was forming in Paris and London after Hitler had invaded Czechoslovakia. This idea did not at all appeal to me, and I certainly preferred to immigrate with my family to the United States. But soon after Pearl Harbor I tried the same game again at the Czech consulate in Washington. This time there was no longer any question of my joining the army of resistance. After all, I was now forty-two years old and did not appear to make a very good fighter any more. Just the same, all kinds of objections were raised, which I was only able to overcome after a friend advised me to "grease the hands a little" of some employees. Eventually I was in possession of four brand-new passports of the Czechoslovakian Republic for Irene, the two boys, and myself. This precaution proved, however, to be com-

pletely unnecessary. It did not occur to the American authorities to consider refugees from Nazi oppression in Austria as "enemy aliens." We were never in any way molested, and I could continue my work at the university without interruption.

We had to move out of our apartment in Newtonville when our landlord got into a scrap with the IRS and was forced to sell the house in order to pay a large fine. We moved into a roomy, rather old house in Newton Center. It was on two floors, with living room, dining room, and kitchen on the ground floor, and three bedrooms with a single bathroom upstairs. There was even a second staircase in this house, which formerly the servants had to use to reach their miserable living quarters in the attic. The house stood close to a nice little lake that offered boat rides and swimming for the whole family. The owner of the house was unhappy about the many repairs the old building needed and desperately wanted me to buy it. He asked only $10,000, a low price even at that time for a roomy house with a garden in a prime location. However, Irene didn't want to be saddled with an antique house, so we finally moved into a small but very pleasant new house which I was able to purchase in Newtonville. It was the first house I had ever owned, and we enjoyed it very much.

One of our reasons for purchasing the house was a cherry tree we saw in full blossom in the garden. To our surprise we got practically no cherries from this tree. Later on a neighbor came to see me and presented me with a bill for cleaning his gutter. When I asked him why I should pay for work on his house he explained: "Sparrows stole the cherries from your tree, sat down on the roof of my house, ate the fruit, and the stones landed in my gutter. This makes you responsible for the bill." I was of a different opinion, but we solved

95

the problem amicably. In this pretty little house, which was conveniently located on a quiet side street near Newtonville's main square, we lived happily for several years. When we finally moved to Santa Barbara I was able to sell it within hours without using a realtor, as it was such a desirable property.

Living in Newtonville, I found out that it was difficult to get around in Boston without a car. Thus, rather reluctantly, I learned to drive, an art which I did not find quite easy to master at my time of life. When I took my driving test, the examiner joined me as usual in my car. When I backed out of the parking space, the first thing I did was hit a water hydrant which was too low to be seen in my rear-view mirror. The inspector got out, examined the situation, and returned, saying dryly, "It's still there, go on." I passed the examination, but I can't say that I was a good driver. I repeatedly got into little scrapes with the police for minor traffic infringements. However, they were mostly straightened out by a friendly neighboring cop whose daughter was a babysitter for us. Only once was I involved in a serious accident. The little boys were in the car and quarreling with each other; I tried to establish peace and thus overlooked a stop sign. A car coming from a cross-street hit me broadside. My car was a complete wreck, and the other driver's automobile was somewhat damaged, but fortunately there were no injuries. This taught me belatedly to pay full attention when driving a car.

Irene also learned to drive; she was never involved in an accident, but she hated driving and avoided it as much as possible. When we later moved to California she happened to witness another lady flunking the driving test while attempting to park her car in the small space between two other parked cars. Thereupon, Irene lost her courage and

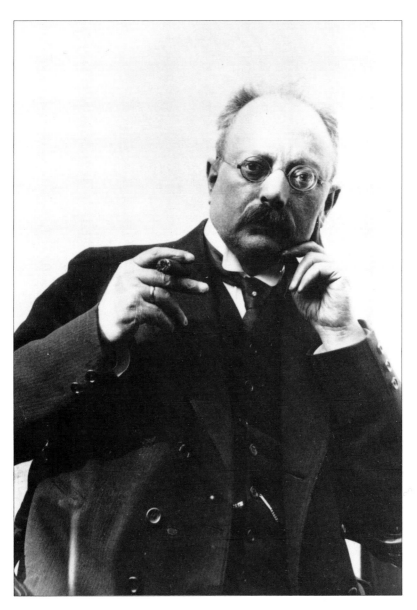

Ludwig Geiringer, Karl's father

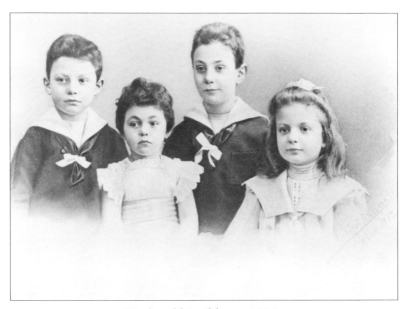

Karl and his siblings, 1904:
Paul, Karl (age 5), Ernest, and Hilda Geiringer.

The Geiringer family, 1906.

Karl and his siblings, 1907:
Paul, Hilda, Karl, Ernest Geiringer

Karl (left) at 18 in the Army, 1917.

Pablo Casals with Karl, 1933.

Karl Geiringer, c. 1950

Irene Geiringer, c. 1945

Karl Geiringer at the opening of the
Stearns Collection, University of
Michigan, Ann Arbor, April 4, 1975.

Martin and George,
Karl's two sons, 1985.

Irene and Karl Geiringer and their
children, c. 1938.

Irene and Karl Geiringer, c. 1980.

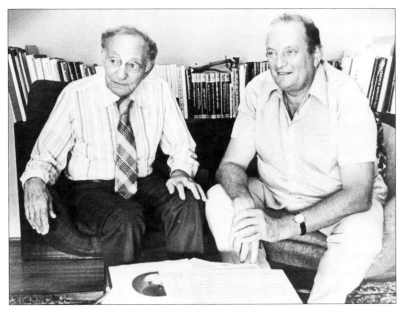

Karl with H.C. Robbins Landon, 1975.

Karl and Jans Peter Larsen, 1985.

Karl and Bernice with Rudolf Serkin (on left).

Karl with Klaus Roy, 1985.

Martin Silver with Karl, 1987.

Bernice and Karl with Dolores Hsu.

For Karl & Bernice. Thank you for the, everlasting beauty you have given me.

Bernice, Thank you for the loving friendship you have given me

Judith *(ANDERSON)*

8-18-88

Bernice Geiringer with Dame Judith Anderson.

Bernice and Karl Geiringer

Bernice and Karl with Ilene Pritikin, 1988.

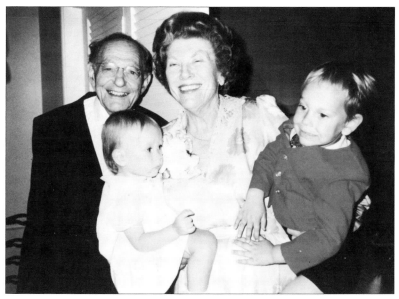

With Bernice's grandchildren, 1987.

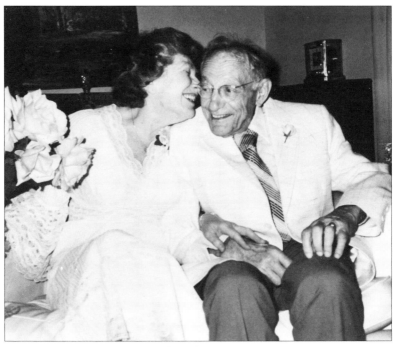

Bernice and Karl Geiringer, 1988.

declared categorically she would not take the driving test. She never drove the car again.

The boys grew up during the years we spent in Massachusetts. At first they went to a public school in Newtonville, but they did not do as well there as we had expected. A counselor we consulted said, "I suspect they are bored. They should skip a grade, and the additional work will offer them a real challenge." The public school was very reluctant to permit this unorthodox solution to the problem, so we decided to enter the children into a private school. With the help of the Homans, an aristocratic Boston family with whom we were on very friendly terms, they were admitted to Meadowbrook School, a delightful, small, very exclusive school in a rural location. The boys had full scholarship, as I could never have afforded the high tuition fee. Each day the school bus came to pick them up in the morning and returned them in the afternoon. In the progressive atmosphere of the school the boys, who had been allowed to skip grade, did very well academically and felt quite happy.

After elementary school, George and Martin attended the famous Milton Academy for a short time. This was a school frequented by the children of blue-blooded Boston aristocrats, who looked down their noses at the sons of an immigrant. The boys felt very uncomfortable there and wanted to leave the school.

At that time George worked during summer vacation at a camp in Putney, Vermont. It was connected with a secondary school where the students, both boys and girls, not only did academic work, but also had to help in the fields and make themselves generally useful on a farm attached to the school. George was thrilled by the unaccustomed activity. On his own initiative he went to Mrs. Hinton, the founder and director of Putney School, and asked her whether he and his

twin brother could be admitted to the fall term of the school. He did not fail to indicate also that they both would need scholarships. Mrs. Hinton liked the courageous young man and accepted the children, who had earned very good grades in their earlier schoolwork, as resident students for the school year. This was a wonderful school with a high academic level, but also stressing sports and farm work. There was also strong emphasis on music. The boys loved to sing in the chorus, listen to records of classical music, and attend the rehearsals and performances of the school orchestra. They were always very busy and quite happy. Even on holidays they sometimes stayed at school. Thanksgiving, for instance, the children invited their parents for dinner at Putney School. This dinner was cooked by the girls and served by the boys. Between the courses, little plays, musical performances, and acrobatic tricks were offered by the students to entertain the guests. These meals, accordingly, lasted from two o'clock in the afternoon until six or seven in the evening.

An interesting feature of the school was also that the students were never shown the grades their work had earned. They were only told by the instructors whether their work was satisfactory, or else they were shown ways to improve it. The exact grades were, however, on record in the school's office, as they would be needed for later admission to a college or university. I want to mention also that Mrs. Hinton did not allow the twins to be together. They lived in different dormitories and attended classes at the same level but with different teachers. She rightly felt that this would further their independent development. They learned to stress their differences more than their similarities, and thus gained in self-assurance.

When they finally graduated from Putney School, the

boys were admitted with scholarships to excellent universities: Martin to Columbia, and George to the Massachusetts Institute of Technology.

At Boston University I had both weak and very promising students. Some of them are today respected university professors and administrators themselves, and I am still in friendly contact with them. Recently Robert Holmes, who had earned a Ph.D. at Boston University, became the president of the Music Academy of the West in Santa Barbara, and we celebrated a happy reunion.

Perhaps my most brilliant student was H.C. Robbins Landon, who came to me because he was very interested in Haydn and had read my Haydn book published in 1932. Landon worked with me on Haydn's symphonies, which resulted many years later in his monumental monograph on this topic. After earning a bachelor's degree, "Robbie" didn't bother to continue his studies. He founded the Boston Haydn Society, which had the aim of continuing the publication of the composer's complete works, started by Mandyczewski in Vienna but discontinued after the scholar's death. Landon's idea was to finance this ambitious enterprise through the sale of recordings of generally unknown Haydn music. I helped as much as I could and also provided jacket notes for some of the records. These records were, incidentally, mostly produced in Vienna, as the cost of hiring union members in this country was prohibitively high. The expected financial success of the venture unfortunately did not materialize. The musical public seemed to prefer buying the tenth recording of Beethoven's Fifth Symphony, or Handel's *Messiah*, to the acquisition of unknown Haydn works. After the publication of only four volumes, Landon's collected edition had to be discontinued and the Boston Haydn Society was eventually dissolved. I have always

remained in very friendly contact with Robbins Landon, who is now a world-famous authority on the music of Haydn and Mozart. Paraphrasing a widely known saying by the wealthy banker, Mendelssohn, "I am nothing but the son of my father [the famous philosopher Moses Mendelssohn] and the father of my son [Felix Mendelssohn-Bartholdy]," I said, "I am nothing but the pupil of my teacher [the great Curt Sachs] and the teacher of my pupil [Robbins Landon]."

My appointment at Boston University was, as customary, for only nine months, and I had a three-month vacation period during the summer. During the first years of my life in the United States, financial circumstances forced me to teach in Boston University's summer school also. This was rather tiring, as I had to meet classes daily instead of twice or, at most, three times a week. Moreover, summers in Boston are anything but pleasant. I recall having once seen a girl student in my classroom who looked particularly miserable. I asked her if I could be of help. "No, thank you," she replied, "it is just this horrible atmosphere that gets me down." I asked her where she came from, since she was obviously not used to our Boston climate. "I live in Phoenix, Arizona," she said. "There we have warm weather in summer, but certainly not this terrible damp heat which is prevailing here." As a matter of fact, our classrooms were badly ventilated—certainly not air-conditioned—and quite inhospitable during the months of July and August.

During some summers I also taught at the University of Southern California in Los Angeles, exchanging jobs with Professor Pauline Alderman. Los Angeles was also pretty hot in summer, the classes very large, and the room in the old building in which we met, anything but comfortable. Nevertheless, the whole family enjoyed the change, especially since USC found very pleasant living quarters for us.

Our first trip to the West was made by car, and the little boys, who were not yet teenagers, had studied maps and guidebooks and planned every detail of the trip. They were particularly good in this respect, and I have always admired their singular gift for finding their way in strange places with compete ease. We also did much sightseeing during these trips, taking the northern route when we went west and the southern route on the return journey. A tiny portable stove which we took along helped us to prepare our simple meals. During the nights we usually slept in inexpensive motels. Thus we spent two glorious weeks on each passage through the American continent.

Gradually my salary at Boston University had somewhat increased, and I was able to stop summer school teaching and could again indulge in our old love of mountain climbing in the European Alps. While we still lived in Vienna we unfailingly went into the country as soon as the library and museum of the Gesellschaft der Musikfreunde closed their doors for a long summer recess and Irene had started her vacation from work at Universal Edition. I recall especially two memorable mountain climbs which we made at that time. We stayed one summer on the western end of Austria and climbed a spectacular mountain which formed part of the border between Austria and Switzerland. We managed to find a very nice Swiss guide and left with him on a pleasantly warm afternoon in July. During the ascent an unexpected thunderstorm broke, and in no time we were drenched to the skin. When we reached the mountain hut in which we planned to spend the night, we had another unpleasant surprise: the little house was overcrowded, and no place for tourists seemed to be available. However, the friendly owner of the hut discovered that one little room was occupied only by a single lady. He asked her whether she

would permit him to put an extra cot into the room so that there would be a sleeping accommodation for Irene. The lady readily consented and thus at least half of our problem was solved. When the friendly girl noticed that Irene and especially I still did not seem to be happy (I was not looking forward to spending the night sitting on a hard wooden bench) she exclaimed magnanimously, "Oh, well, why don't we push the two beds together and there will be room for the three of us." This we did. It was the only night in my life I spent lying in bed between two ladies. Nothing very interesting happened, however. All three of us remained fully dressed, as it was bitter cold in the drafty room. Moreover, we were all nervous, for we knew that we would have to get up at four in the morning for an early breakfast so as to be able to cross the glacier that separated us from the mountain peak before the sun came up and softened the snow, making the passage more difficult and dangerous.

All too soon a glorious brilliant summer day dawned, and we reached the summit without any particular difficulty. We were pretty hot from the sunshine and the exertion of the climb and happy to find a shady place for our rest between the rocks. "Wouldn't a glass of ice cold beer taste good now? our guide pleasantly remarked. I wholeheartedly agreed and he asked, teasingly, "How much would you give for it?" I answered, laughingly, "Fifty francs." "Fifty francs is not enough," he retorted, "How about one hundred francs?" I said, "Okay, okay," and quickly forgot the matter as we started to eat the sandwiches we had brought along. In the middle of our little meal we discovered that our guide had disappeared. After half an hour he was back again grinning happily and holding a large bottle of ice-cold beer. It would be an understatement to say that we were surprised. I asked him: "For heaven's sake, how did you manage to get hold of

properly chilled beer miles and miles away from human habitation?" He said, laughingly, "First drink, then pay me the 100 francs, and then I will reveal my secret." He later explained to us that during the dead season in the fall, when tourists no longer climbed the mountains, the idle guides carried knapsacks full of beer bottles to the summit, burying them in a sheltered cave under a thick layer of snow for later sales to thirsty customers.

Another summer Irene and I spent in the Alps included an experience which was not so pleasant. We decided to climb the Grossglockner, Austria's highest mountain, but when we arrived in the village from which the ascent was usually made, we found that all the guides were on their way with other tourists. We heard, however, of an old hunter living in the village. He was not a licensed guide, but had often climbed the mountain, and we were assured that he was completely reliable. Rather hesitantly, we engaged him, and during the ascent to the mountain hut at the foot of the summit he appeared to be not exactly friendly, but quite competent. Arriving at the refuge, which was at an altitude of about 12,000 feet, my first action was to vomit violently. The thin air, combined with the exertion of the climb, had provoked an attack of strong mountain sickness which, however, gradually passed.

The next morning we made the ascent to the summit. We each had an ice pick, crampons on our boots, and were secured by a strong rope. This was necessary, as we had to traverse a narrow grade with deep vertical drops on both sides. Just at this spot, our hitherto quite taciturn guide found his tongue and entertained us with remarks like "Right here a party of five tourists lost their footing and fell down to their death," and pointed out, "Here a group of four was surprised by an avalanche and could not be saved."

It can be easily imagined how we liked these remarks during the perilous climb. However, we reached the summit without any accident, enjoyed the glorious view, and returned safely to the mountain hut. To our surprise the old man then stated casually, "From here on you don't need me any more; you just have to follow the footprints in the snow from our ascent and they will take you to the valley again. I wish to remain in the hut." We had no choice but to leave him and go on our way unaccompanied. At first the walk was not difficult and quite pleasant, but soon we discovered to our dismay that the firm snow cover, which had supported us during our ascent, had been burned away by the hot sunshine of the summer day. Suddenly we were in the midst of open crevasses which we could only avoid by making detours and occasionally by jumping over openings in the ice. At one particularly tricky spot I jumped over a wide gap and just managed to reach the other side safely. Irene followed me, but her legs were shorter than mine and she did not quite make it and slipped into the deep crevasse. Fortunately I held her hand. She was small and not very heavy and, with a super-human effort, almost pulling her arm out of its socket, I managed to pull her to my side and avoid a catastrophe.

We were both exhausted, however, and it was quite some time before we were able to resume our descent. When we finally arrived dead-tired in the village, we found a telegram from my mother, who was spending a vacation with my sister Hilda in another mountain resort. She notified us that Hilda had suddenly fallen ill with a serious intestinal ailment and the doctor felt that an operation might be necessary. Surgery could not be done in the small mountain village, and mother needed my help to bring Hilda back to Vienna. Thus we were forced to disregard our fatigue and leave almost immediately to assist in transporting the patient to

the city. Fortunately, Hilda's illness proved to be not as serious as had been feared at first; but the events of these days have always remained a frightful memory to me.

Traveling from Boston to the Alps in Austria, Switzerland, or France was quite costly. In order to save money we usually took charter flights. They were not convenient, usually overcrowded, and the time of departure and arrival was never quite certain. Usually we had to arrive early in the morning at the airport and then wait several hours before the plane actually left. Our return flights were equally delayed, sometimes even for several days, and once our flight was canceled entirely. We had to fly back on a regular commercial airline, which was very costly. The food we received during the long hours of passage was also anything but attractive. But all this did not bother us too much, and we were happy to be able to enjoy the beauty of our beloved mountains again, particularly when our two sons could get away from their summer work and accompany us.

We also visited Vienna frequently, staying in a delightful little pension right in the heart of the city. It consisted of a small number of tiny, self-contained apartments, each with a bedroom, living room, bathroom, kitchenette, and its own telephone. The transformation from the old, rather sleepy Vienna into a bustling metropolis filled with traffic and tourists from all lands was quite startling, but the city retained its charm for us. Although badly damaged during the war, Vienna was quickly rebuilt and now looked even prettier than before.

Research Work in Boston

As soon as a certain routine had been established in my teaching schedule and I felt I was standing economically on firmer ground, I started on my own research work again. My first project was to complete a book on the history of musical instruments. This work had been started earlier in Vienna and I had even concluded a contract with an Italian publishing house to print and market it, but I never seemed to find the necessary time to complete the project. In England, too, I had worked on the manuscript; however I only completed it in Boston. Finally *Musical Instruments: Their History from the Stone Age to the Present Day*, partly translated by Bernard Miall, was published in 1943 by Allen and Unwin, the firm that had also issued my Brahms book. The American edition came out in 1945 under the imprint of the New York office of Oxford University Press.

Textbooks on musical instruments usually deal with the different types of instruments in systematic order. My book, instead, used a historic arrangement of the material. In seven chapters the instruments of the West are treated from earliest times up to the present, thus covering close to 25,000 years. This method enables the student interested in the music of a specific period to find all the information about the instruments in use at that time in a single chapter. On the other hand, the reader interested in a particular instrument can easily trace its development with the help of the table of contents and the index of the book.

My *Musical Instruments* had a commercial success which neither I nor the publishers had anticipated. Between 1943 and 1965 it had to be reprinted five times. When finally the sixth printing seemed necessary I decided to rework the whole material, updating the contents with the help of more

recent research. In addition, the somewhat amateurish inves-
tigation of the acoustics of the instruments was sharply cur-
tailed, while each chapter of the new book opened with a
thumbnail sketch of the musical trends of the period, with
special emphasis on the general cultural and artistic aspects.
This new book entitled *Instruments in the History of Western
Music* was only completed after I had retired from the
University of California. It was published in 1978 by Allen
and Unwin and by Oxford University Press. A German
translation, which I provided immediately afterward, was
issued by C.H. Beck in Munich in 1981, both in hardcover
and in a paperback edition.

My second great love, next to musical instruments,
belonged to the work of Haydn. At all times it has been
close to my heart and mind. Early in 1932 the Austrian con-
ductor, Hans Rosbaud, had asked me to find an interesting
unknown Haydn work for him to perform over the
Frankfurt radio. I sent him the score of a charming little
comic opera, *La Canterina*, a work which was at that time
still quite unknown. Irene and I provided the German trans-
lation of the original Italian libretto. The amusing plot deals
with a singer of easy virtue who has two lovers; a very young
and handsome boy, and an old and rich man who supports
her. The latter discovers her duplicity and threatens to
throw her out of his house, in which she is living. With the
feminine technique of tears and the threat of suicide she
softens the enraged man's fury, and at the end of the comedy
she wins both men back and they shower her with gifts. The
young boy brings her some jewelry he has stolen from his
mother, while the older man gives her money. Haydn
assigned the part of the boy to a cherubic character, a girl in
man's clothes. Moreover, at the first performance, the part of
the singer's maid was entrusted to a man singing falsetto. In

Rosbaud's performance the part of the young lover was sung by a boy with a clear soprano voice, which was much better than a female singer. The maid's part had to be sung by a woman, as it was not possible to find a man who could sing the whole part falsetto. The piano score of *La Canterina* with the German translation we had provided also appeared later in print.

At the occasion of the Haydn centenary I edited the most famous composition with which the composer had been wrongly credited. it was the *Feldpartita* in B-flat major for eight wind instruments, which C.F. Pohl had considered to be a genuine work of Haydn and shown as such to Johannes Brahms. The master was impressed by the work and used one of its movements, the "Chorale St. Antoni," as the theme for his magnificent *Variations über ein Thema von J. Haydn.* Although the original piece is definitely not by Haydn and its author is not known, it is a fine composition which, together with the other three movements of the work, deserves to be revived. I also offered for the first time in print one of the numerous baryton trios Haydn had written for his patron, Prince Nikolas Esterházy. Nikolas had been a passionate amateur performer on this particular long-since-obsolete instrument, constantly urging his music director to provide suitable new compositions for him. The baryton was a cello-like instrument with a large number of gut strings and additional metal strings *under* the fingerboard. The primary function of these additional strings, which could not be reached with the bow, was to sound sympathetically when a tone was played. The baryton's neck was open on the rear side so that the player was also able to pluck the metal strings with the thumb of his left hand. Two completely different effects, produced by both bowed and plucked strings, could therefore be achieved on the same

instrument. Haydn wrote more than 160 compositions for his patron; most of them were trios for baryton, viola, and cello. In my transcription of Trio no. 82 I replaced the baryton, which is today practically unknown, with a violin, thereby transposing the whole part with good effect an octave higher.

I also edited one of the *Notturnos* commissioned by an exalted patron using an antiquated instrument. The *Notturnos* were written for a small orchestra using a pair of lira organizzatas as solo instruments. This particular instrument was favored by the king of Naples, who commissioned Haydn to write a number of works in which the monarch could participate playing his favorite instrument. The lira organizzata was a kind of large violin on which the strings were played not with a bow, but with a wooden wheel inside the instrument activated by a crank. The strings were not shortened with the fingers of the left hand, but with the help of a number of piano-like keys. In order to enlarge the possibilities of the instrument a tiny flute organ was also enclosed in the instrument's body, the necessary wind being pumped by bellows activated by the rotation of the crank. The player thus had a chance to produce, either separately or jointly, the sounds of a bowed string and of a woodwind instrument. Haydn himself replaced the obsolete favorite of the king of Naples with two wind instruments in later performances, and I did the same in my edition.

After the completion of the book on musical instruments it was my great wish to produce a new Haydn biography. The time to undertake this venture seemed propitious. Recent research, especially by the Danish musicologist, Jens Peter Larsen, had gradually advanced our knowledge of Haydn's artistic activities and helped to distinguish between the authentic and the numerous spurious works attributed to

the composer. Irene now had time available, as she had given up a teaching job she had held at the beginning of our stay in Boston. She had worked in a small private college; the student body was ill-prepared and the pay not very good, and it didn't seem worthwhile to undertake the tiresome trip from our apartment in the suburbs to the center of Boston several times a week. Thus it was possible for us to collaborate again on a book as we had previously done with the Brahms biography. The respected publisher of musical textbooks W.W. Norton in New York was interested in the project, and we went ahead with the work, Irene writing most of the biographical section while I concentrated on the discussion of the music. It was our ambitious plan to produce a manuscript in the English language for the first time without the help of a translator.

Our work made slow but steady progress, and in 1945 we were able to deliver the manuscript to the publishers. Professor Paul H. Lang of Columbia University, who served also as Norton's music editor, discreetly revised the text to avoid Germanisms. However, an unexpected obstacle suddenly arose. The firm of Athenaion in Potsdam, East Germany, which had published my Haydn book of 1932, learned about our project through an advance notice issued by Norton. The German firm immediately protested against the new publication. They claimed that, according to our old contract, they also owned the translation rights to the book. This biography had been a single volume in a series of twelve musical biographies of different composers. They would only permit the publication of the English Haydn if Norton undertook to also issue the other eleven volumes of the series at the same time.

This was obviously a very unfair demand. It would have been very difficult for any publisher to commit himself to

such a gigantic undertaking. In this case it was quite impossible because the series also contained biographies of Bruckner and Reger which were of little or no interest to the general music-loving public in the English-speaking countries. We pointed out that our work represented a completely new book on Haydn and was by no means a translation of the earlier work. The Haydn biography of 1932 provided only an outline of Haydn's life, twenty-eight pages in length, while the same section in the new book was more than six times as long. The old book arranged the compositions of Haydn according to categories, dealing first with chamber music, then with symphonies and overtures, etc. For the Norton book, on the other hand, we had chosen a grouping of the compositions according to periods of Haydn's life, beginning with the works of his youth and ending with his last great achievements. We tried to explain all this to the German firm but had no success at all. They remained adamant; it was everything or nothing.

Finally I had no alternative but to take the matter to court if I did not want several years of work by Irene and myself to go to waste. This was not easy technically because we had to find a lawyer in East Germany to present our claim in the Berlin court. We finally succeeded in acquiring the services of a reputable attorney, and he presented our case in such a convincing way that the German judge decided the case in favor of the American plaintiff and against his own countryman. Athenaion was forced to agree that the objections against the publication of the English language book were unfounded, and the firm even went so far as to return all the rights of the German book to me.

The Norton book was duly issued in 1946 and it was quite successful. Allen and Unwin in London printed an English edition in the following year, and eventually

Swedish, Japanese, Hungarian, and French translations followed. These editions in foreign countries were all secured by a very efficient member of the staff of Allen and Unwin, while my own contribution to the transactions consisted mainly in accepting the royalties.

In 1947 Oxford University Press, New York, acquired also the rights to a second edition of our Brahms book, as Houghton Mifflin in Boston was no longer interested. This book, too, did very well. Translations into Italian, Hebrew, Japanese, French, and Russian were gradually issued. I might mention that of these translations the Russian was the only unauthorized one. They contacted neither our publisher nor me. They paid no royalties and did not even send me a copy of the book. I have never seen it, and only learned of its existence through a trade journal.

Oxford University Press, New York, was now handling two of my books, the *Musical Instruments* and the Haydn. They were pleased with the sales and wanted an additional book. The firm's main editor visited me in Boston and asked me what my plans were. I said that I did not consider writing another book as I could not afford the means of doing the necessary research for a new project. The gentleman accepted this answer, and we agreed only that we might meet again the next time I came to New York. I duly gave him advance notice when business called me to that city, and he invited me to have lunch with him. When I arrived at the exclusive restaurant I found the editor sitting with another gentleman who was introduced to me as Mr. Barrett. We had a delicious meal, and when dessert was served Mr. Barrett asked quite casually what my next book project would be. I told him also that I had no plans. "How about a study on Beethoven?" he asked pleasantly. I laughed, "That is out of the question. I know nothing about the countless

musical sketches Beethoven made or about the numerous conversation pads he employed during his increasing deafness to communicate with other people. It requires a lifetime of research to become familiar with the material that forms the basis of any serious research on the music and life of Beethoven." He continued his interrogation, "How about Mozart?" I turned this down too. "There are already a few very good ones," I replied, "and quite a number of bad ones. I would not be able to produce a really good one, and I don't wish to provide an addition to the bad ones."

Mr. Barrett now made his third attempt, "How about the Bach family?" he asked. This idea immediately took my full attention. I had always been greatly interested in this family, probably the only one of its kind in human history, in which creative genius manifested itself through so many generations. While still living in Vienna I had already edited a volume of clavier music written by various members of the Bach clan who had lived between 1604 and 1845. This was a fascinating idea, as I immediately told the two gentlemen. Mr. Barrett did not comment on my remark. He excused himself, as he had to attend to some business, and left us. Thereupon I asked the editor, "Who is this Mr. Barrett?" He told me he was the head of the Bollingen Foundation, initiated and supported by Paul Mellon in memory of his late wife. Mrs. Mellon had been a devotee of the great Swiss psychologist, Carl Gustav Jung, and had visited him frequently at his home, called "Bollingen." As she was an enthusiastic music lover, Mr. Barrett promoted the publication of books on music through the Bollingen Foundation. "No doubt you will hear from Mr. Barrett again," the editor said when we separated.

And so it happened; a few weeks later a letter reached me in Boston from the Bollingen Foundation offering me a

grant of $10,000 to write a book on the Bach family. At that time $10,000 was a very substantial amount, and it was hardly possible to turn down the offer. Thus it didn't take Irene and me very long to notify the Bollingen Foundation of our acceptance.

Our first concern now was to secure the necessary biographical material. Since very little information had been provided by earlier research, and because the members of the Bach family had been active in different cities of Saxony which were now located in East Germany, we thought it would be necessary to do research in these places to obtain essential information. We decided to spend our next vacation in Europe and to travel to the cities involved. In good time we applied for visas to enter the German Democratic Republic and made the necessary preparations for a trip that summer. But week after week passed, and our various applications produced no result. We had made an appointment to meet the director of the Leipzig Bach Archives, Dr. Werner Neumann, in Eisenach, the birthplace of Johann Sebastian Bach, and we flew to Europe hoping that a miracle would happen and we would be able to do some fruitful research in the various Bach cities with Dr. Neumann's help. We took a train which brought us to the border and there, of course, an East German soldier came into our compartment and demanded to see our passports. When he saw that we had no East German visas he was amazed. We tried to explain to him that we had applied several weeks earlier for the visas, and if he would send a telegram or make a phone call to Berlin at our expense he would certainly find out that our visit was permitted. He hardly listened to our explanation and said curtly, "Come with me." No choice was left to us but to grab our luggage and follow him. He marched us to a little waiting room with wooden benches and told us to stay

there. Anyway he locked the door as he left. Several hours later he appeared again and took us to a train standing in the station ready for departure. It took us back into West Germany. Dr. Neumann waited for us for forty-eight hours. He was greatly disappointed that we never appeared.

I was forced now to attempt a different solution of our problem, and this time I was successful. I wrote to the mayors of the Thuringian cities in which members of the Bach family had been active and asked them to put me in contact with scholars who could do the necessary research for me. I would, of course, remunerate them for their efforts. This approach worked well. So soon after the end of the war, it was not too difficult to find scholars who badly needed work. Moreover, I did not pay them with money, but rather sent articles which were hard to get or even unobtainable in East Germany at that time. Packages with sugar, rice, chocolate, cigarettes, and other scarce items were exchanged for important biographical data. Particularly fruitful were my contacts with Mr. Paul Bach (a member of the clan, though not a direct descendant of Johann Sebastian), a man working for the postal service in Eisenach. Mr. Bach produced not only biographical material, but also a number of miniature pastels painted by one of his ancestors. Among these tiny portraits was an excellent likeness of C.P.E. Bach, Johann Sebastian's son, and also a hitherto unknown miniature reputedly representing the Thomas cantor himself. Paul Bach was quite willing to let me have reproductions of these miniatures, and he asked me to send him the necessary color film, which was unobtainable in East Germany at that time. I did so and he duly snapped the pictures. The next difficulty was that nobody in Eisenach was able to develop color film. He therefore mailed the unprocessed film to me. I was very much afraid that the censor at the border would want to

examine the content of the mysterious undeveloped film sent out of the country and thus destroy the image. To my pleasant surprise, however, the film spool had not been touched, and I was able to obtain excellent reproductions.

The most interesting among the newly acquired pictures was, of course, the portrait of Johann Sebastian which had been almost unknown so far. C.P.E. Bach, Sebastian's great son, had already mentioned in his correspondence that he owned a pastel portrait of his father. This likeness remained in the family and belonged to Mr. Paul Bach. Charles Sanford Terry, the great English Bach scholar, wanted to buy it from Mr. Bach, but it was not for sale. At present, since Paul Bach is no longer alive, I believe it is owned by his married daughter, who resides in Munich. The pastel was painted by a kinsman of Johann Sebastian, Gottlieb Friedrich Bach (1714-1785), who was the great-grandfather of Paul Bach and the son of Johann Ludwig Bach (1677-1731), a composer whose cantatas Sebastian liked to perform after he had copied the manuscripts in his own hand. Since the picture had never been reproduced before, Oxford University Press asked me to let them publish it in a little brochure they issued for the Bach year 1950. We called the booklet "The Lost Portrait of Bach," and I provided the necessary explanatory text. The Gottlieb Friedrich miniature shows features closely resembling those in the well-documented Leipzig Bach portrait by Haussmann. However, the Thomas cantor of the pastel seems friendlier and more relaxed, the kind family man, rather than the strict professional cantor painted by Haussmann for the Mizler'sche Societät, a learned society which Sebastian was about to join. I included this remarkable picture also in my later Bach publications.

I also established a friendly personal relationship with

Paul Bach, and he presented me with several small oil paint-
ings, both of the outside view and of the interior of the Bach
house in Eisenach. He had painted them himself, and they
are quite well done, considering that he was an amateur and
his occupation in the post office left him very little time to
pursue his hobby. I still have the miniature paintings in my
living room hanging above the piano.

It was not only difficult to procure biographical material
for our new book, it was equally complicated to reach the
indispensable musical sources. The Preussische Staats-
bibliothek in Berlin, which had been the repository of most
of the Bach material, no longer existed. During the Second
World War it was felt that the treasures of the library, which
was located in the center of the city, were not safe from aerial
attacks. It was decided to remove most of them and to dis-
perse them all over Germany. They were housed in various
salt mines, as these places were completely dry and safe from
bomb attacks. At the end of the war, when English, French,
and American troops entered West Germany, they found
these treasures and distributed them to various libraries.
Music came to the universities of Marburg and Tübingen.
They were in a perfect condition of preservation. Likewise,
those scores which had remained in Berlin were intact, as the
building had escaped destruction. However, the rather sub-
stantial amount of music which, during the war years, was
stored in the eastern part of the country, occupied by the
Russians, had disappeared. A very small part of these trea-
sures trickled back in later years, while the present location
of the majority of them cannot be ascertained definitively. It
appears that Polish libraries are holding most of them.

Fortunately, the directors of the various libraries, espe-
cially those in Marburg, Tübingen, and Berlin, as well as the
head of the Leipzig Bach Archives, were very cooperative.

They readily sent me microfilm copies of the available scores I needed to see. I thus assembled quite a sizable collection of little-known works by various Bach composers (a collection, incidentally, which I recently donated to the Music Library of the University of California at Santa Barbara). I purchased a microfilm reader, which enabled me to study these scores comfortably at home.

Our work on the new book progressed slowly but steadily. As before, Irene concentrated on the biographical sections while I dealt with the music. We finally produced quite a substantial volume. *The Bach Family—Seven Generations of Creative Genius* comprised 514 pages in its printed form. Oxford University Press in New York and Allen and Unwin in London issued the book simultaneously in 1954. It was quite successful. Eventually it also appeared in Italian, French, Dutch, and Spanish translations. Irene and I produced a German translation, which was issued by C.H. Beck in Munich.

There were also immediate results from the publication of the book. The Library of Congress in Washington, D.C., invited me to deliver one of the coveted Elson Memorial Lectures in their Whittall Pavilion. I accepted, of course, and on May 23, 1955, I read a paper on "Symbolism in the Music of Bach." The director of the Harvard University Press amicably chided me, "Why didn't you show the manuscript of your book to us? We would have loved to publish it." To console him I assembled a number of mostly hitherto unpublished compositions by fourteen members of the Bach clan (excluding only works by Johann Sebastian himself). This collection, entitled *Music of the Bach Family, An Anthology* was duly published by the Harvard University Press in Cambridge, Massachusetts, and was recently reprinted by Da Capo Press, New York.

Another direct consequence of the publication of the Bach Family book was also my election in 1955 as president of the American Musicological Society. I had been in close contact with the AMS since I first came to the United States. Being one of its earlier members, I was also accorded the rather dubious distinction of serving as chairman of the Program Committee for one of the Society's regular yearly meetings. This meant a lot of correspondence with various members who wanted to read papers, evaluating numerous abstracts, and grouping them in a meaningful way. Quite a few suggestions were made which I did not like, and I had to refuse them in polite and friendly letters. On the other hand, members of the Society whose names I wanted to appear on the program had to be coaxed into sending me an abstract.

I also chaired the New England chapter of the Society for many years. This involved finding suitable speakers for each of the regular regional meetings, which was not always easy. I felt quite relieved when my friend, Otto Gombosi, who had recently joined the Harvard faculty, was elected to the chairmanship, thus freeing me from a burdensome task. It was a different situation to be the president of the whole Society, which in the meantime had greatly enlarged its membership. There was a board of directors and a treasurer, who took most of the administrative duties off my shoulders. Thus the presidency was no great burden; rather it was an honor, and much fun. I served the usual two-year term, 1955 and 1956, and most of my work was to preside over board meetings and the yearly membership meeting.

Unfortunately, there was also a negative aspect of my stewardship. It was a great disappointment to me that my friend Leo Schrade, a professor at Yale University and an eminent scholar, was not elected president after me. The nominating committee duly put his name on the ballot

together with that of a practically unknown and undistinguished teacher from the Midwest. Leo's election therefore seemed certain, and I nearly forgot the matter. The next day I casually asked one of the vote counters, "Well, how did he win?" "Oh, he won handsomely," was the answer. "I am so happy," I exclaimed. "Schrade is certainly a fine scholar and they could not have elected a better man." "I am afraid," the vote counter retorted, "Schrade lost by a wide margin." I had not even considered the negative vote and that Schrade, who was rather self-possessed and not particularly friendly, was rather unpopular among his colleagues. They refused to vote for him although his opponent was hardly known to them. Schrade took this defeat far too much to heart. He wanted to get away from it all and accepted an invitation to a professorship at the University of Basel, Switzerland, a school which neither in prestige nor in resources was equal to Yale.

Family and Friends

Despite a few negative aspects, I enjoyed the presidency very much, which later also led to my being elected to honorary membership in the Society. Both Irene and I were happy, especially since our life in Boston was so comfortable and pleasant. Some members of my family lived nearby. My sister, Hilda, who was chairperson of the department of mathematics at Wheaton College in neighboring Norton, Massachusetts, frequently came to see us. Eventually she even moved to Cambridge for permanent residence after resigning from her position at the college, which she had never enjoyed very much. In Cambridge she only did research, and she was finally able to share living quarters with her hus-

band, the Harvard professor Richard von Mises. Richard was an outstanding scientist who had been rector (president) of the Berlin University before he came to Harvard. He was also an ardent collector, and had assembled a magnificent collection of objects, books, and music pertaining to the German lyric poet Rainer Maria von Rilke. After Richard's death this collection, whose catalog alone fills a volume of substantial size, became the property of Harvard University. Mises had a rather stiff and not particularly outgoing personality, and I was always a little uncomfortable with him. However, he was very kind and helpful, and I was quite sad when he died of cancer at a comparatively early age.

Hilda's daughter, Magda, also was a resident of Boston. She is a fine woman, and I and especially my son Martin, who lives close by in Rhode Island, have always been in close contact with her, and we still are. Magda studied at Bryn Mawr College and later taught German at the Massachusetts Institute of Technology. She gave this up and later worked for a large firm specializing in the sale of valuable old German books. At present she has her own business and is very respected and successful in her work. Magda was married to a medical doctor, Dr. Robert Buka, and they had three children. He was an excellent doctor, and I not only consulted him professionally but liked him very much as a person. A terrible tragedy ended his life prematurely. One night a fire broke out in his home, and both he and one of his children perished in the flames. It took many years before Magda married again, this time to a former professor in the Massachusetts Institute of Technology, Dr. Laszlo Tisza, a theoretical physicist whose work is widely respected. Magda and Laszlo now live in a beautiful home in a Boston suburb, where I was their guest several times for prolonged stays which I always greatly enjoyed.

My brother Paul and his family likewise lived for a while in the Boston area. We saw them often and spent many pleasant hours in their company. Unfortunately they moved to New York after a few years, as Paul found better professional opportunities there.

Among our personal friends I should especially mention Dr. Edith Vogl, a musicologist from Czechoslovakia, who had settled down in Boston. Edith occupied a large, old-fashioned but comfortable home in Brookline, in which she still lives today. It has a large living room with two pianos in it, and Edith, who is an accomplished pianist, likes to play eight-hand music. Her house, which she shared with an older sister and, later on, also with a much younger husband, was always filled with music and open to guests. Irene and I enjoyed the friendly atmosphere and liked to attend parties there, where we were sure of good music and excellent European-style food. Edith was on the faculty of Boston University for a while, teaching vocal accompaniment. However, she left the school when we left.

Our special friends, and even benefactors, were the members of the Homans family. They were aristocratic "blue-bloods" of Boston society who felt strong interest in and love for those who were less privileged. When we first came to Boston with a letter from Mr. Root of Clinton, New York, they immediately invited us to stay in their house. Mrs. Homans even took care of our little boys while Irene and I tried to find appropriate living quarters. Later we repeatedly "rented" their delightful vacation home in Martha's Vineyard for prolonged stays during the summer months. We paid the ridiculous amount of $50 for the season, and Edith Homans always acknowledged receipt of the check with the remark that our payment was "very welcome." To Edith Homans I later dedicated my book on musical instruments.

Our Haydn biography was dedicated to another great lady, Elizabeth Sprague Coolidge, "whose courageous promotion of contemporary chamber music would have greatly pleased the father of the string quartet." Mrs. Coolidge was a great patroness of music. She gave a substantial amount of money to the Library of Congress in Washington, D.C., enabling them to build a concert hall equipped with a fine organ, and also commissioned the composition of new works by contemporary composers. Yale University, as well as a hospital for crippled children, likewise benefited from her largess. When Irene and I had the privilege of knowing Mrs. Coolidge better we were struck by the simplicity of her lifestyle. She occupied a modest and not particularly comfortable apartment in Cambridge, which did not give the impression that the occupant was financially well-off. Her interests belonged only to the furtherance of music. She was an accomplished pianist herself and tried her hand also at music composition. It pleased her to have my boys sitting on each side of her on the piano bench while she played and sang little children's songs for them with text and music written by her. Mrs. Coolidge never missed a concert of chamber music in Boston or Cambridge. In later years, when she became a bit hard of hearing, she usually sat in the first row with a small black box at her feet which contained a hearing aid connected to her ears. Irene and I never ceased to marvel at the energy and enthusiasm of this remarkable lady!

We likewise entertained friendly relations with various members of the Harvard faculty. Edward Ballantine was a prolific composer and a very good pianist. It was a bit tragic, however, that of all his numerous and often very ambitious compositions only one was really successful. It consisted of two sets of piano variations on the children's song "Mary

Had a Little Lamb," in which each variation imitated the style of a different great composer. We liked these amusing and rather clever pieces, and he himself played the technically difficult music with great brilliance and verve. Edward had a very friendly personality, and we saw quite a bit of him and his charming wife. Unfortunately he was professionally not very successful because he was completely overshadowed at Harvard University by the famous composer, Walter Piston, whose works were frequently performed and who had also written several highly successful textbooks on music theory. Edward never made it to a full professorship, though he had tenure for many years.

We also saw quite a bit of Archibald Davison and his much younger wife; they belonged to the circle of people we liked best in Boston. He was one of the great teachers on the Harvard faculty. His classes on music appreciation and the history of music had to be held in a large auditorium, which was always so crowded with students that many of them had to be satisfied with standing room. Davison was a brilliant pianist and illustrated his lectures with performances of all the pieces he discussed. Often he also enlisted the help of an assistant, and they provided memorable renditions of music from various centuries.

Wallace Woodworth was the conductor of the Harvard Glee Club and the Radcliffe Glee Club. Although I didn't have much direct contact with him, he sponsored my election to a fellowship in the American Academy of Arts and Sciences, in which he occupied a rather prominent position. Irene and I liked to attend the meetings of the Academy, where we always met prominent scholars and artists and heard interesting lectures after partaking of drinks and good food. I am still a fellow of the Academy, though by now with emeritus status.

John Ward and his crippled though very charming wife, both specialists in Renaissance music; Tillman Merritt, an expert in the field of counterpoint; Elliot Forbes, a conductor and renowned Beethoven scholar; and, most of all, my good friend Otto Gombosi, who died unexpectedly shortly after his appointment to the Harvard faculty; all belonged to our little circle of close acquaintances.

Willi Apel, a lecturer at the university, was at that time working on his *Harvard Dictionary*, and he asked me to contribute the articles on musical instruments. I would have loved to accept the invitation, but Apel had only limited financial resources and I was unable to donate much time to work that was not remunerative. Thus, regretfully, I was forced to decline. I, however, remained in friendly contact with this scholar, whose versatility, self-discipline, and tremendous energy I greatly admired. Apel later became a professor at the University of Indiana, which has a large number of graduate students and confers many doctorate degrees in music every year. Apel made it a habit to leave Bloomington on the last day of school to spend the vacation doing research in his summer house. Thus a little joke was coined: "A doctor a day keeps the Apel away."

Altogether I had many pleasant acquaintances on the East Coast. In particular there were the Drinkers in Philadelphia, of whom we were very fond. Henry Drinker was a respected lawyer, but his great passion was music. In his beautiful home he regularly arranged amateur concerts of large-scale musical works for voices and orchestra. Every instrumentalist and vocalist in Philadelphia was invited, and Henry himself conducted with more enthusiasm than skill. The great choral works of classical literature, like the *Missa Solemnis* and the Bach B-Minor Mass, were run through. Hardly ever was anything corrected or repeated, and the

music sounded pretty bad. However, the performers enjoyed themselves and accordingly accepted Henry's invitations. The Drinkers asked us to join them twice on such occasions, and they even generously paid for our sleepers on the train.

Mr. Drinker's second passion was translating foreign texts of vocal compositions into English. He was a firm believer in the creed that in America vocal music ought to be sung in English. Thus he produced singable translations of the vocal works of Bach, Schubert, Schumann, and Brahms, and even of Russian songs. However, he had to overcome great difficulties in his work, as he had not mastered foreign languages. He needed competent helpers to provide literal translations for him of the foreign texts, which he then transformed into poetic and singable verses. Irene and I did this and we liked the work, which was not difficult and for which Henry paid quite well. The finished translations were also handsomely printed at Drinker's own expense, and he made them available free of charge to anybody who wanted to use them.

In retrospect, it appears that this idealist's efforts and expenses were wasted. The old argument about whether to sing vocal compositions written in foreign countries with their original texts or translated into the language of the country in which the performance took place has long been settled. The use of the language chosen by the composer himself is now generally accepted. This policy certainly brings the work of art closest to the audience; but to make it really effective certain procedures and rules ought to be followed:

(1) Voice teachers should train their pupils to articulate foreign languages clearly. This is frequently neglected, especially by American singers who present songs in concerts in half a dozen languages, pronouncing the words quite unintelligibly.

(2) Every piece of vocal music should be printed or per-
formed together with a literal (not poetic or singable)
English translation, so that the singers as well as the
audience are completely familiar with the meaning of
the words.

(3) The American habit of darkening the auditorium
during performances should be discontinued in con-
certs of vocal music, so that the audience can com-
fortably follow both the original text and its transla-
tion in their programs.

(4) The excellent idea of projecting the translation of the
text of operas on a screen above the stage should be
generally adopted. Audiences of the San Francisco
and Los Angeles Operas are very pleased with this
innovation, which theaters probably learned from
television.

Sophie, Henry Drinker's wife, had a strong interest in the
role of women in music. She quite systematically collected
material on this subject, and her painstaking research
extended from primitive cultures, antiquity, and the Middle
Ages to modern times. She wrote an extensive study, *Women
in Music*, which Irene and I translated into German, and it
was published under the title *Die Frau in der Musik*. Henry
and Sophie were so filled with ideas about their particular
musical interests that they arranged between themselves
days on which they would discuss his problems exclusively
and other days which were devoted to her preoccupations.

In Philadelphia we also met Mrs. Curtis-Bok-Zimbalist
again, whose acquaintance we had made long ago in Vienna
when she visited the archives of the Musikfreunde. She was
the founder of the famous Curtis Institute of Music, where I
would have loved to be employed as a teacher. However,
they only teach performance and composition and there was

no place for an historian. Mrs. Zimbalist received Irene and me in the most friendly manner and invited us for a weekend stay in her magnificent summer home in Maine. We gladly accepted and spent two very pleasant days there. Mrs. Zimbalist entrusted us also with an interesting German translation of a book. She had acquired a large selection of hitherto unpublished Wagner letters, and John Burke, the program annotator of the Boston Symphony Orchestra, edited them in English translations with an extensive introduction and detailed commentaries. Irene and I provided the German version of the preface and commentaries and revised the original German texts of the letters. This work, too, was not difficult but was well paid.

We also had some good friends in New York. I was particularly fond of Gustave Reese, the eminent author of works on music of the Middle Ages and the Renaissance. He was the first person who showed me genuine friendliness when I came to America the first time. On the second day of my stay in New York I made telephone calls to persons to whom I had recommendations. One gentleman, completely unknown to me, was immediately gushing on the telephone. "How wonderful to hear your voice again. We must have lunch together very soon. Too bad that I have to go on a business trip tonight." So he chattered on in a very friendly manner. At the end of the conversation he asked rather casually, "What was your name again? I did not quite get it." This experience rather discouraged me and was one of the reasons why I attempted to return to England as quickly as possible. However, on the same morning I was invited to lunch with Gustave Reese, who was friendly and understanding. He took me to an excellent restaurant where we had a pleasant conversations, and he displayed much warmth and support. In later years I have often visited Gus in his

cozy apartment in New York, and he and his charming wife were also overnight guests in our house. I was elected several times to the board of the American Musicological Society, both before and after I became its president, and our meetings mostly took place in the New York Public Library. It was almost a ritual that we all went to the Reeses' apartment afterwards for some refreshments and a convivial chat.

In New York I also saw Paul Henry Lang. This Hungarian scholar had studied in Germany and France but was now a professor at Columbia University. He was, as I believe I mentioned before, the music editor at W.W. Norton, and greatly improved our sometimes inept use of the English language in our Haydn book. He himself mastered English and I have repeatedly quoted sentences from his monumental work *Music in Western Civilization* in my own books. Paul also helped me with a strong letter of recommendation for a coveted Guggenheim grant. This enabled me to travel to Austria during a period of sabbatical leave to study the church music preserved in the Esterházy castle at Eisenstadt. Prince Esterházy, who was an ardent Hungarian patriot, had been annoyed when, at the end of World War I, the Burgenland, which had originally belonged to Hungary, became a part of the new Austrian Republic. He removed all objects of value—among them the precious Haydn original manuscripts—from his castle in Eisenstadt, the Burgenland's capital, and stored them in his Budapest palace. The church music, consisting mostly of eighteenth-century copies, was left behind, as it was considered to be of lesser significance. Ironically, the castle of Eisenstadt with everything it contained was almost the only thing the Prince was able to keep after the Second World War, as the communist regime in Hungary confiscated his Hungarian property. So, in Eisenstadt I was now able to study an important collection

of Haydn's music, used in his own time, probably under his supervision. The essay I wrote about this subject was later published in *Musical Quarterly* and the German version in *Kirchenmusikalisches Jahrbud*.

I also must confess that I once acted against the strong advice of my friend Paul Lang. I received an invitation from the Hungarian government to participate as their guest in a big Haydn celebration held in Budapest in 1959. Paul was of the opinion that it was unadvisable and dangerous to travel behind the Iron Curtain, but I did not share his fear and went anyway. I am happy I did it, because this trip was a wonderful experience and of great significance for my later work. The international guests who arrived at the convention were treated royally by their hosts. We found luxurious accommodations and excellent food; and, most important of all, the treasures of the National Library (largely former Esterházy possessions) were made fully available to us. I luxuriated in studying countless Haydn original manuscripts, the hand-written materials Haydn had used in the performances at the Esterházy Opera House, as well as other treasured documents. In particular, my attention was attracted to the original parts which had been used by the singers in Haydn's opera *Orlando Paladino*. These valuable documents showed that the soloists were not given piano scores, but simply their own parts, into which the necessary cues were inserted. A figured bass replaced the original orchestral accompaniment. The parts were, moreover, full of little annotations and corrections in Haydn's own hand, and they induced me to deal quite thoroughly with Haydn's *Orlando Paladino* at a later date.

In Budapest I also met Professor Rudolf Gerber, who had recently started the publication of a collected edition of Gluck's compositions. I told him that Guido Adler long ago

had asked me to edit in the *Österreichische Denkmäler* Gluck's opera *Telemaco*, written for Vienna; but that somehow this plan had never materialized. Gerber was interested, and we agreed to keep the matter alive, which later led to very interesting work for me.

During the years I spent in Boston I also established friendly contacts with the Baroness Germaine de Rothschild, who had literary talents and was very much interested in music. Her son-in-law, the great cello virtuoso Gregor Piatigorsky, suggested that she write a biography of Boccherini, who had composed a great deal for the cello, and I received a letter from her asking for some information regarding Boccherini's relationship to Haydn. On a visit to Paris, Irene and I visited the charming lady in her *palais* in Paris. She gave us tea and showed us the magnificent collection of Italian Renaissance majolica works of art she and her husband had collected. We greatly admired the wonderful large vases, bowls, and cups, of which any museum would have been proud. Quite casually, the Baroness remarked, "I must tell you, we are so very grateful to Field Marshall Göring." We could hardly believe our ears, but she explained, grinning, "When the Germans entered Paris in World War II they came with an exact list of our collection of art works. Göring immediately confiscated all our treasured majolicas and had them transported to his own castle. Before they left Paris, however, he had made an elegant leather box lined with silk for each of these delicate pieces so that they would be safe during the transport. When the Allies occupied Germany they found our collection in perfect shape in Göring's castle and returned everything to us. As a bonus we also received all the valuable leather cases in which they had been transported." These cases were also shown to us, and we were duly impressed.

The next year our two sons made a summer trip to Paris and also visited the Baroness. She invited them to attend a big party she was giving the next day for a young relative. The boys would have been glad to accept, but confessed that they had not taken formal clothes on their trip and could, therefore, not attend the ball. "This is no problem," responded the Baroness. She rang a bell and told the butler to provide Martin and George with some tails of his own the next day. The butler complied, and the two boys had a lovely time at the ball.

The Rothschild–Göring episode reminded me of a humorous remark in the preface to the fourth edition of *Grove's Dictionary of Music and Musicians,* issued in 1939. The editor, Dr. H.C. Colles, stated there, "The editor feels himself to be under some obligation to the totalitarian states which have sent him some of his most valued contributors. He could not have had such fine contributions from foremost authorities in their several fields as Dr. Egon Wellesz, Dr. Karl Geiringer, Dr. Hans Redlich, and Dr. Alfred Loewenberg, had they not been residents in England."

Altogether our lives in Boston were satisfying. We had relatives and friends nearby. Our little house in Newtonville was comfortable, my position at Boston University was secure, and I had the assurance that I could teach full-time as long as I was able and willing to do so. I developed a certain teaching routine which left me sufficient time for my personal research, and, last but not least, the cultural life in Boston—its first-rate libraries, fine concerts, excellent theaters, and stimulating lectures—was highly appreciated by both of us.

New horizons

T HOUGH OUR SITUATION in Boston was stable and we had every reason to feel contented, I gradually got a bit restless. The prospect of teaching at Boston University to the end of my professional life seemed gradually less and less attractive to me. My existence seemed a bit too well regulated. I progressively got bored and ready for a change.

An opportunity seemed to offer itself when Leo Schrade relinquished his position at Yale University. He invited us to New Haven and told me quite directly that he would like to see me become his successor at Yale. The prospect seemed attractive, but there was also a serious drawback. Leo showed us his house, which was a real antique, probably more than one hundred years old. It was, of course, rebuilt later, but we still found it uncomfortable and uninviting. Leo implied—though he never clearly stated—that he would like us to buy the house if we moved to New Haven. As we showed very little enthusiasm for the dwelling, barely hiding our dislike, he did not pursue the matter any further, but I never received an official invitation to join the Yale faculty.

A positive opportunity offered itself after the retirement of Pauline Alderman from the faculty of the University of Southern California. I was known at the school through my teaching during various summers, and thus I was offered the open position. However, Irene did not like Los Angeles, the bustling wide-spread city where you can only get around by driving a car (which Irene hated to do) and which is smoggy and unbearably hot in summer. Moreover, the pay offered was not very attractive. Thus I refused the offer, with some regret.

Around this time I received an unexpected telephone call from Dr. Samuel Gould, who had been vice president of Boston University and whom I knew slightly. He asked me if I would be interested in coming to Santa Barbara. I was taken aback by this question. I had visited Santa Barbara once or twice before when I taught summer school at USC; however, I could not see that I would have a professional future in such a small community. Dr. Gould explained to me that an important branch of the University of California was located in Santa Barbara and that he was going to be appointed chancellor of its campus. He wanted to strengthen its promising music department. He told me some more about the advantages of the position, and we finally agreed that I would come to Santa Barbara for one semester as a guest professor. This would provide the university with an opportunity to look me over, and I would be able to decide whether I really liked teaching there. Thus Irene and I came to Santa Barbara for a few months. We stayed in a small but very attractive little guest house in the middle of a large garden in Mission Canyon on the estate of a Mrs. Pierce. At the end of the semester I returned to my regular duties at Boston University.

Before long I got a second telephone call from Sam

Gould: "What's the matter, Geiringer? I thought by now you would be teaching in Santa Barbara." I explained to him that there were many things which I had enjoyed while teaching at UCSB but there were also matters I disliked which made the position seem unattractive. He wanted to know what the negative aspects were. I explained to him that: (1) there was practically no music library, only a handful of books and very little music. This made the teaching of the history and theory of music very difficult, if not impossible; (2) the music department offered only a bachelor's degree, and, while I like to teach undergraduates, I need the stimulation of working with graduate students as well; (3) I had learned that the customary retirement age at UCSB was sixty-seven, and as I was already sixty-two years old it seemed hardly advisable to make such a radical change for such a short time; and finally (4) the salary offered to me was not very attractive.

Dr. Gould listened to all this and finally said only: "Hm, I will see what I can do."

After a month or two he telephoned me for the third time. "I think we can fulfill your various wishes. There doesn't seem any reason why a graduate program, with the necessary library backup, couldn't be established at UCSB." Dr. Gould guaranteed that I could teach full-time beyond age sixty-seven, if I was able and willing to do so; and, finally, the salary offer would be sweetened. There was only a small condition attached to the invitation which I did not like. Dr. Gould wanted me to assume the chairmanship of the music department. This did not appeal to me. I thought it to be thankless administrative work which could easily lead to friction with colleagues and the dissatisfaction of the dean and chancellor. I therefore said I was not really suited for the chairmanship and recommended instead a younger

faculty member, Dr. Roger Chapman. Dr. Gould followed my advice. Roger and I have become very good friends, which was also helped by the fact that his wife, Cornelia, and Irene liked each other.

Everything was now settled, and Dr. Gould and I agreed in principle that I would join the UCSB faculty in the fall of 1962. The arrangement of details was made with the new chairman of the music department, Dr. Chapman. Valuable help was also provided by my friend Bill Hartshorn, supervisor of music in the city of Los Angeles, who traveled on my behalf to Santa Barbara and finalized negotiations. I had met Bill, who was a very fine musician, during my summer teaching at USC, and we had spent many pleasant hours together. Bill had also conceived the rather strange idea that I should, at least temporarily, write the program notes for the Los Angeles Philharmonic Orchestra. He proposed to notify me in good time of the planned program schedule and was willing to check my notes for stylistic imperfections. This was an amusing possibility and I actually provided the annotations for three seasons.

Finally all the formalities with UCSB were settled. I gave up my position at Boston University, quickly sold my house in Newtonville, and Irene and I moved permanently to California.

In Santa Barbara we bought a comfortable home on the "Riviera," as that part of the city is usually called. The house had some disadvantages, such as a small kitchen, practically no dining room, and the best of the four bedrooms had no exit into the hallway but only into a second bedroom. However, this house was very well located in a quiet neighborhood and had a nice garden with a beautiful large patio offering complete privacy. From some windows there were also attractive views of the harbor and city. We rebuilt and

greatly enlarged the dining area and added a second bath-
room to the largest bedroom. Gradually we grew very fond
of the house and now, after twenty-six years and many basic
changes in my lifestyle, I still live in it and have no intention
of moving unless circumstances force me to do so.

In the fall of 1962 I actually started teaching at UCSB.
From the beginning I found the atmosphere in the music
department friendly, cooperative, and helpful. I never expe-
rienced the rivalry and professional enmities which so often
crop up in universities. My ideas were, of course, challenged
at times but more by events than by persons and I always
maintained cordial and friendly contacts with all those with
whom I had professional relationships.

At the beginning my main aim was to get the necessary
tools for my work. I needed music, books, records, and film-
strips so that I could project musical scores in the classroom
while analyzing the compositions. I went to the director of
the UCSB library, Dr. Donald C. Davidson, and asked
rather timidly, "What is the yearly library appropriation for
the music department?" The question seemed to disconcert
him somewhat and, after some hesitation, he answered,
"About five hundred dollars, I think." I thanked him for the
information and went to consult with my colleagues in the
department. We made up a list of the most pressing needs,
and although I did not know the exact price of any of them,
I am sure altogether they cost far, far more than Dr.
Davidson had allotted to us for the whole year. I took the list
to Mrs. Martha Peterson, who was in charge of library
acquisitions, and there was no protest of any kind. We
speedily received all we had requested. This encouraged me
to presently send in second and third lists of desiderata, and
there was never any refusal by the library administration. As
soon as I had the necessary scores I went to the visual aids

department and asked them to produce the filmstrips neces-
sary for my teaching from the music.

I felt that the establishment of a strong music library was
essential for the growth of the department. It had become a
kind of unwritten rule that colleagues always came to me
with lists of desiderata for their work, which I collected and
passed on to the purchasing department. But this method
was slow and not sufficiently effective. We needed major
acquisitions to be really efficient. Opportunities to reach this
goal offered themselves sooner than I had expected. A friend
of mine, Eric Hertzmann, professor of musicology at
Columbia University, spent a semester as a guest teacher at
UC Berkeley. We saw quite a bit of each other and enjoyed
the meetings, but then, rather unexpectedly, a catastrophe
happened. Eric, who had always been in frail health, seemed
to have taxed his strength too much. He fell seriously ill, and
his life could not be saved. His widow found herself in
strained circumstances and was willing to see her husband's
large library go to us. Although the cause for this purchase
was very sad, I was glad that our department could thus
acquire a really good-sized library of books and music. This
happened after the death of one friend in 1963. A second
friend died in the following year. Leo Schrade could not
enjoy his new activity in Basel for a long time. I was shocked
when I learned of his passing away at the age of sixty-one.
This time, again, his widow was willing to sell us part of
Leo's library.

By now we had acquired really good resources. We
needed a professional full-time music librarian, and we
found him in the person of Martin Silver, who came to us
from the New York Public Library in 1967. He and his very
able assistant, Susan Sonnet Bower, further greatly improved
the facility. Our collection of recordings grew in size and

quality. Much material available on microfilm only was now incorporated into the library. Its physical plant was also greatly improved and modernized. The music library is housed above the arts library in spacious quarters (which by now, in 1988, are not adequate anymore, owing to the steady expansion of the holdings). The main compositions of the musical literature which are in constant demand by faculty and students, are now reproduced on tapes so that the records don't wear out. Students listen to them with the help of earphones placed conveniently in certain sections of the main reading room. There are also listening rooms in which the occasional and unavoidable use of the records themselves is possible. The facilities also include a microfilm room equipped with several readers, and the library subscribes to all the current major American and European musical magazines. A special technician works on the production of tapes and other study aids. By now we can safely say that UCSB's music library compares favorably with that of any college or university with an enrollment of fewer than twenty thousand students.

I was not so fortunate in my attempt to strengthen the offerings of the music department in my own teaching field. I tried to acquire the help of Dragan Plamenac, an eminent historian who had done particularly important work in the field of fifteenth-century music. Dragan came and taught at UCSB for one semester. He did not make any special contribution to our offerings, and left at the end of the allotted time. Neither he nor the students seemed to feel much regret. The same happened with a professor at the Paris Sorbonne, the composer-scholar Jacques Chailley. He came to us from France, where I had first met him years before. At that time Chailley invited me to lunch in Paris, where he introduced me to the unforgettable, typically Alsatian "chou

croûte," a delicious mixture of boiled pork and cabbage. In Santa Barbara he was as charming and sparkling as ever, but somehow his teaching left no impression. He, too, left at the appointed time.

We seemed to have better luck with Sylvia Kenney, a very promising scholar who had done especially important work on early Renaissance music. Sylvia seemed to like Santa Barbara and the University, and I hoped that she would develop into a permanent helper in my field. However, she was engaged at the rank of associate professor, and her promotion to full professorship still seemed to be years away. Thus she could not resist when Smith College in Massachusetts offered her a full professorship in 1966 after she had been with us for one year. Tragically, she could not enjoy this important promotion for a long time either. In 1968 she passed away quite unexpectedly at the age of forty-four.

At last we had better luck with Theodor Göllner, who was with us during the last years of my full-time teaching at UCSB. He had been strongly recommended to me by his teacher, Professor Georgiades at Munich University, and also by my friend, Professor Fellerer in Cologne. Theo was strong in the field of early medieval music, but his interests were more catholic and he had also done highly successful work on compositions of later centuries. He and I have remained good friends up to this time, even after he left the university to accept a call to the coveted chairmanship of the music department at the University of Munich, which was vacant after the retirement of Prof. Georgiades.

A problem that arose during the early stages of Theo's tenure at UCSB was successfully solved. His wife, Marie Louise, who works very successfully in the same field as Theo, was unhappy that she had no opportunity to use her

talents in Santa Barbara. However, she accepted a position at the University of California in Los Angeles, where she spent several days weekly while maintaining the couple's beautiful home in Santa Barbara, to which she returned regularly. This somewhat unusual arrangement has been practiced to the present. The couple now has four homes, one in Los Angeles, one in Santa Barbara, one in Munich itself, and one in the vicinity of the Bavarian capital. They commute back and forth between these different places. Theo spends as much time as he can in California, while Marie Louise joins him regularly in Munich during vacation time. The couple's son, a student at UCLA, lives with his mother, while the older daughter works in Washington, D.C. Altogether, this rather unconventional scheme seems to work extremely well.

At the end of December 1967 we had the opportunity to serve as hosts for the yearly meeting of the American Musicological Society. I had fought for this distinction for many years, but my colleagues on the board of the Society preferred larger cities for the meetings, and so objections were always raised. Nevertheless, I had my way at last, and a good-sized number of our members came to Santa Barbara. Most of the meetings took place in the Miramar Hotel, and although the meeting rooms were a bit small and not all the guests could be accommodated in the Miramar itself, everything worked out well. My colleagues, Professors Stanley Krebs and Douglass Green, took care of the local arrangements and provided regular bus transportation between the various Santa Barbara motels and the Miramar. Our main performance took place in the theater on campus. Haydn's *Dramma Eroicomico Orlando Paladino*, to which I had been introduced in Budapest many years earlier, was performed in an English translation provided by Carl Zytowski, who also conducted the opera. The Santa Barbara performance,

though done with student singers and a student orchestra, was lively and entertaining and greatly enjoyed by the audience. In particular, the highly amusing arias of Pasquale, the servant of Orlando, who was ably interpreted by Ed Kemprud, were received with great hilarity.

Personally I was impressed by certain similarities of the work to Mozart's operas, particularly *Don Giovanni.* In both operas three comical and three serious characters appear, while the central figure—Don Giovanni in one case, Orlando in the other—are half-tragic and half-comical characters. Both works pass through dramatic complications but end happily, although in the case of *Don Giovanni* the hero is first eliminated before the remaining characters enjoy themselves. Finally, Pasquale's marvelous aria in which he enumerates his countless travels all over the world while never able to satisfy his voracious appetite for food, seems similar to Leporetto's aria in which he enumerates Don Giovanni's trips throughout the world conquering more and more female hearts and always remaining dissatisfied and hungry for more conquests. There can be, of course, no question of a direct influence. It is most unlikely that DaPonte and Mozart knew *Orlando Paladino,* but the two operas grew out of the same artistic soil and were intended for similar kinds of audiences.

The second production offered during the AMS meeting was directed by my friend Professor Putnam Aldrich of Stanford University. It was a sixteenth-century ballet, which Putnam performed together with a group of students. They were in costumes of the time, accompanied by Renaissance instruments, and they strictly followed the rules of contemporary textbooks in their movements. It was a memorable, quite unusual experience.

My vital interest in *Orlando Paladino* was prompted by a

kind of second phase in my Haydn research. Originally I had tried to provide a complete picture of Haydn's artistic and human personality. Later I wanted to investigate more thoroughly the specific fields of his production. I had started out with his arrangements of folk songs of the British Isles. I felt particularly attracted to this topic because folk songs always interested me very much and also because Haydn research had consistently neglected it. I knew, of course, that these arrangements were not really representative. Haydn received the melodies without text, and he wrote his accompaniments without any knowledge of the specific character of this kind of music, just providing simple and technically undemanding accompaniments. Nevertheless, I found the problem challenging, and to begin I made a catalog of all the arrangements known to me. This catalog was photographed on a microfilm, and I presented copies of it to the British Museum in London and the Library of Congress in Washington, D.C. Then I wrote a study about the topic for *Musical Quarterly*, and, finally, I edited the first hundred arrangements in a volume of the collected Haydn edition. I continued my work, extending it to some of Haydn's later arrangements. However, questions arose about the authenticity of some of these arrangements. It appears that Haydn occasionally enlisted the help of his pupil Neukomm for this routine work, without indicating this in the manuscripts he delivered. I began to lose interest in the work and first enlisted only the collaboration of the Haydn scholar Dr. Irmgard Becker-Glauch, but eventually I ceded the whole work to her.

My next Haydn project, which I have mentioned before, dealt with the smaller church compositions. Then came *Orlando Paladino*, which I edited again for the collected edition. This took a great deal of time, but I found it most

rewarding. The best part of Haydn's extensive original manuscript has been preserved, and it clearly demonstrates how quickly he worked, rarely changing his mind, although he himself occasionally suggested cuts, apparently on the basis of his experience during early performances. A welcome secondary source was also provided by the parts of the singers, which I have already mentioned; and, finally, there was a manuscript score with a German translation of the text that had been sent to Haydn for his approval from a theater in Mannheim. The composer began to correct the German text in accordance with his own ideas, but he did not finish the job. He never returned the score, apparently because he intended to continue his revision at a later time. The score remained in his library, and was taken over first by Prince Esterházy and eventually by the Budapest National Library. Irene and I carried on the revision of the German text as well as we could, and our score with German text was published by Bärenreiter Verlag in Kassel. For the publication of the work in the *Collected Edition* I had, of course, used Haydn's original Italian text only.

The pleasant intellectual climate at UCSB was also supportive of our literary activity. Ironically, the work which required the least effort had, from a practical point of view, the greatest success. I realized that in our book, *The Bach Family*, the section dealing with the life and work of Johann Sebastian generally met with the greatest interest. We therefore decided to lift the chapters devoted to the Thomas cantor out of the context of the earlier work, to enlarge and update them, and thus to create a new book which incorporated the results of newest research. We entitled it *Johann Sebastian Bach: The Culmination of an Era*. It was published not only in the United States and in England (1966), but gradually also in Swedish, Hungarian, French, Japanese,

Portuguese, and Spanish editions. Eventually we also translated the book into German, and this book, published in 1971, has already gone through three printings.

We also felt that our Haydn book needed a new lease on life. My friend and former pupil H.C. Robbins Landon had produced a gigantic five-volume Haydn biography which incorporated both the results of earlier research and his own exhaustive studies. This important work also offered an incentive for us to revise and update our own earlier book.

Irene and I changed and enlarged almost every paragraph of the old Haydn book, and it was published by the University of California Press in Berkeley in 1968. The finished product was quite handsome, and we were very pleased to have found an excellent new publisher. Eventually the book also appeared in Japanese, Swedish, and Hungarian translations. About the German translation, which we produced ourselves and which was only published in 1986, I shall report later.

In Santa Barbara I also attempted excursions occasionally into fields I had not cultivated before. I wrote an article about the structure of Beethoven's "Diabelli" variations, which was published by *Musical Quarterly*. Following an invitation by Gustave Reese to contribute to a collection of essays "In Honor of Curt Sachs," I investigated the Protestant funeral song "Es ist genug" from Ahle's original composition in the seventeenth century through Bach, Brahms, and, finally, to Alban Berg in the twentieth century.

I also returned to an earlier field of research and edited Isaac Posch's *Harmonia Concertans*, a collection of sacred concertos for voices and instruments from the first half of the seventeenth century. Soon after I had finished my university studies I had edited instrumental works by Posch in the *Österreichische Denkmäler*. Forty years later I rounded off

the research. With the exception of a single collection of instrumental dances, which was not available when I worked for the *Denkmäler,* I have now edited all the works known to exist by this highly significant Austrian composer.

With the *Harmonia Concertans* I also started a new series of musical publications for which I assumed responsibility as general editor. The *University of California, Santa Barbara, Series of Early Music* was first published by University Microfilms in Ann Arbor, Michigan, and later taken over by the Theodore Presser Co. in Bryn Mawr, Pennsylvania. Three of its first issues contained Posch's concertos and two *Musiche* by Marco da Gagliano (1615), edited by my friend Putnam Aldrich of Stanford University. Seven more were edited by different former students of mine, who were thus provided with an opportunity to publish material they had collected for the work on their doctoral dissertations. None of the editors, nor I myself, received any payment for this work, which was quite time-consuming. The arrangement with the publisher was that we provided the calligraphy of the music on transparent paper. The publishers handled the printing and the necessary publicity and paid a royalty of 20 percent to the university. It would seem that this was a bargain for UCSB; nevertheless I found it difficult every year to raise the approximately $1,000 needed to get the necessary photographic reproductions of the source material and to pay for the calligraphy of the music. At first the research committee of UCSB rather reluctantly financed the enterprise. Later the music department took over and tried unsuccessfully to get a research grant from the government for the work. Finally I got tired of the constant hassle and gave it up. I have offered the general editorship to various colleagues, who always showed great interest in the enterprise. So far, however, nobody has actually taken up my

offer. Chancellor Huttenback was quite intrigued with the whole enterprise and urged me to continue it; however, I could not make up my mind to do so.

New Developments

During the earlier part of my work at UCSB our family was very pleasantly enlarged. In 1962 Martin married a very nice former student of mine, Bonnie Reid, and in the following year George married Janet White, a beautiful English nurse who was on a prolonged visit to the United States. Bonnie was a serious-minded, hard-working girl. She was willing to shoulder a substantial part of the household expenses while Martin, who had earned a Bachelor of Arts degree from Columbia University, New York, and a Master of Science in electrical engineering from Stanford University, completed his studies for a Ph.D. in biophysics at UCLA. Bonnie was a friendly, energetic, and resourceful girl. I liked her and occasionally still hear from her and her mother. Unfortunately Martin and Bonnie were gradually estranged from each other. It may not have been the fault of either of them, but they could not live together any longer, and in 1971 they were divorced. Since there were no children and there was no property to speak of, the separation was quite simple.

George's marriage developed quite differently. He and his bride were not only in love with each other at the beginning, they have remained so for twenty-five years. George had graduated with a Bachelor of Science degree in mechanical engineering from M.I.T. and a Master of Science degree in nuclear engineering from the same institution before his marriage. In 1969, while working as a senior engineer at TRW Systems, he earned an additional degree in Aerospace

Engineering from the University of Southern California. Janet showed full understanding of the strain imposed upon George by this double activity, and their marriage was, if anything, strengthened by it. They both wanted to have children, and their wish was fulfilled. Erika arrived in 1964, Karen two years later, and Kevin one year later. All three children are grown up by now. They are beautiful and very industrious young people.

All three are attending universities with excellent scholastic results. Erika earned a bachelor's degree in child psychology from the University of Arizona in Tempe. After two years of practical experience, she has now entered the graduate school of the University of Rhode Island, where she is doing her graduate work plus, at the same time, working as an assistant, thus earning her tuition as well as receiving a handsome salary. Karen finished her undergraduate work at UCSB with a double major in political science and business administration. She was always on the dean's list, and at graduation she earned a special prize for high achievements. She plans to work now for a year in a business firm to gain some practical experience before entering graduate school. Kevin studies architecture at the University of California in Berkeley. However, he is spending his junior year at London University in England, not far from his mother's family. All three children are a joy to their parents and, needless to say, also to their grandfather. Both Janet and George work very hard to make it financially possible for three children to attend college practically simultaneously. George is a principal engineer in the Space Systems Division of Ford Aerospace Corporation in Palo Alto, California. Janet works as a nurse in a hospital not far from her home in Foster City, California. She works from 3 to 11 P.M., so that she and George do not see as much of each other as they would like.

I get along extremely well with all the members of my family, but unfortunately I cannot see as much of them as I would like to: Martin lives on the East Coast in Rhode Island, and George in Foster City, near Palo Alto. Nevertheless, we manage family reunions several times a year.

As I mentioned before, these two sons of mine are very different from each other. Martin is full of brilliant ideas and imagination. He is a typical scholar intent on solving problems. He has done successful work in the field of brain research. Although he is an excellent teacher who understands how to present information to his students in an interesting and compelling manner, he is no longer teaching at Northeastern University in Boston and has just returned to his beloved research. I can only hope that he will receive the necessary grants to pursue his work in the coming years. Now his domestic life is fortunately on firm ground again. He married Patricia Cristofaro, a doctor of internal medicine, in 1986, and they have a charming and extremely well-developed little son, Daniel. Pat has a very good position in a hospital, and they live happily in a very pleasant home in Greenville, Rhode Island. Martin is a very good husband and they both are extremely proud and affectionate parents.

If Martin, in a way, lives to some extent in the future, George has both feet solidly on the ground. He is certainly not lacking in imagination, but he sets himself goals which he is sure to reach. He is an excellent husband and a very good father, successful in his work, popular with his colleagues, and held in high esteem by his superiors. I am very proud of both of my sons.

My seventieth birthday was quite a big event and pleasant experience. There were actually three different types of celebrations. First, the music department at UCSB invited me to conduct a concert of the student orchestra with the univer-

sity chorus. The program was chosen by me, and I used only music which I had rescued from oblivion. Two good friends of mine sang the solo parts: Ruth Michaelis, contralto, and Carl Zytowski, tenor. My brothers came from New York and attended the concert. During the intermission the Austrian consul-general from Los Angeles handed me the Austrian Cross of Honor for Achievements in Science and Art. (He attached it to my buttonhole, and the first thing that happened was that it fell to the floor, to the great amusement of the audience.) Rudi Garrett, who had come with his wife, Edith Vogl, took pictures of the celebration and presented them to me. I recently looked at them again, and am shocked to notice how completely the human situation had changed in the nineteen years since the photos were taken. Many people in the pictures are no longer alive; others have moved away and I have lost contact with them; and still others I do not even recognize anymore. It was a most unpleasant reminder of passage of time.

The second stage of the celebration was provided by my good friend Martin Silver, our music librarian. For several weeks he had regularly come to our house on the days on which he knew I was teaching at school. Irene showed him the cabinet where I kept the reprints of my articles, and he compiled a complete, practically faultless list of all my publications. It was given to me in the form of a handsome little booklet of fifty pages with the title "Karl Geiringer: A Checklist of his Publications, University of California, Santa Barbara." Five hundred copies of this checklist were printed in Santa Barbara in April 1969.

The best present, and the greatest surprise, came from Irene. She mobilized my former student and faithful friend Robbins Landon and asked him to edit a Festschrift in my honor. He was willing to do this on condition that he would

not have to shoulder the various technicalities involved in the work. Therefore Irene approached Roger Chapman (I have always entertained very pleasant relations with him and his family), who kindly agreed to collaborate. Actually, most of the work was done by Irene. First of all, she secured the necessary support of publishers. Both Allen and Unwin in London and the Oxford University Press in New York were willing to print the Festschrift on condition that a title of general interest to musicians was chosen. Of course they would not pay any royalties, nor would they expect financial assistance for the publication. The title agreed upon was *Studies in Eighteenth-Century Music, a Tribute to Karl Geiringer on his Seventieth Birthday.* Letters went out to various scholars and personal friends inviting each to contribute an essay to the volume. The letters were signed by Landon and Chapman, but actually they all were written by Irene. Eventually thirty-eight contributions came—four from British, eight from German, one from a French, one from a Hungarian, and the rest from American musicologists. Landon provided a brief but very charming foreword, and Martin Silver's list of my publications concluded the volume of 425 pages, which also contained my photograph. As the publishers insisted that all the articles be in English, Irene undertook the herculean task of translating the eight German contributions into English (the French and Hungarian contributions were already in English). The volume contained several very significant articles which have been repeatedly quoted by other authors. The book sold well in spite of its very high price and had to be reprinted. It is still available through Da Capo Press in New York.

The end of my full-time teaching at UCSB was a bit anti-climactic. After my seventy-second birthday I decided that it was time to make room for a younger person. I resigned and

Theo Göllner, who had been promoted to the rank of full professor, took my place. There was a little celebration in the music department for Roger Chapman and me, the two professors who were retiring at the end of the 1970–71 school year. Roger is at least ten years younger than I am, and I never found out what caused him to resign, since he was generally liked and held in high esteem by students and faculty. We both received handsome silver wine coolers from the faculty as presents. Mine has the inscription:

KARL GEIRINGER

FOR OUTSTANDING CONTRIBUTIONS

UCSB MUSIC DEPARTMENT

JUNE 1971

To my surprise I found out that freshly retired faculty members from a university are in demand by other schools as part-time teachers. The University of Louisville, in Louisville, Kentucky, invited me to come as their Bingham Professor of musicology for a semester. I had to teach two classes, one in romantic music of the nineteenth century, the other on the music of Joseph Haydn, and the pay was good. I accepted with pleasure, and Irene and I had a very good time in Louisville. The students were well prepared and the faculty friendly and cooperative. Gerhard Herz, the main professor and a Bach scholar, invited us to his house repeatedly, and so did one of my pupils, Mrs. Patricia Updegraff, who was not really a university student but who came regularly to each of my classes. She always brought some knitting to the class and worked assiduously while I spoke. This irritated me a little bit, but I gradually got used to it. Pat was an ardent music lover and often took us to the rehearsals and performances of the excellent Bach Choir, where she was a

member of the board. Pat, who is now a grandmother, has remained a good friend. She never misses a birthday of mine and always telephones or writes a note on April 26. I might mention that Louisville also had a very good orchestra whose conductor at the time we stayed there was, if I am not mistaken, Lawrence Leighton Smith, the present director of the Music Academy of the West in Montecito.

The University of Louisville was not the only school that invited me. The chairman of the music department at the University of Missoula in Montana telephoned me and asked whether I would be willing to teach in their summer school. Irene and I thought that this would be a novel and interesting experience, and I accepted the offer. Missoula proved to be an attractive little city in the mountains, and we made a number of lovely excursions into the neighborhood. The academic preparation of the students was not too good and I had to keep our work on a low level. Nevertheless I found the experience rewarding, and I still remember with great pleasure the beautiful landscape around Missoula. One of my students, Larissa Janczin, accompanied me back to Santa Barbara. She continued her studies at UCSB and earned a master's degree there. At present Larissa is teaching full-time at a junior college near San Diego.

A third invitation came from Northwestern University in Evanston, Illinois. They also wanted me to teach in summer school, and I rashly accepted, not knowing what a suburb of Chicago was like in summer. My classroom was not air-conditioned, nor was the apartment in which we stayed. I had to meet classes of over fifty students every day, and the temperature remained close to one hundred degrees for six weeks. Both Irene and I found it very hard to work and difficult to sleep, and we even lost quite a bit of weight. The occasional visits to the Chicago Art Museum and to the Ravinia Music

Festival did not make up for the unpleasantness of the climate.

I also attempted to do some part-time teaching at UCSB. At first this did not work; they did not really need me and had no money to pay me adequately. I did offer a class, but there were not many students, and officially Theo Göllner was the instructor, although I did the work. This discouraged me, and I made no further attempts to resume my former activity.

Quite a series of accidents and attacks of illness made teaching impossible anyway. Irene started the cycle of misfortunes. We were on a summer vacation in the eastern Tirol and had climbed one of the neighboring mountains. I was a little ahead of Irene and when I heard her shouting, "Karl! Karl! Come and help me!" I quickly returned, but I arrived too late. She had inadvertently stepped into a hole between the rocks and could not withdraw her foot. A burly tourist next to her observed her predicament and wanted to be helpful. He grabbed her and, as she was small and light, easily extracted her from the hole, but in the process broke her foot. He walked away unaware of the damage he had caused and left her lying on the ground crying with pain. The situation was desperate. We were on top of a mountain and there seemed to be no assistance available. Suddenly, however, another tourist appeared, and he offered his help. He walked backwards downhill the whole length of the mountain, half-carrying Irene and indicating where she should put her healthy foot. With his help and the little support I could give, we finally brought her into the valley. There the man summoned an ambulance, and as soon as it had arrived he disappeared. I never found out his name, nor did we ever hear from him again. We had the feeling an angel from heaven had come to the rescue. The doctor in

the little village fortunately had an X-ray machine, and he diagnosed a rather nasty break in the right foot. He put the leg into a cast and we moved to Vienna as soon as we could. There we could only find accommodations in a hot and very noisy pension, and Irene, who had to stay in bed most of the time, felt very uncomfortable. As soon as she was able to move again, at least with the help of crutches, we returned to Santa Barbara.

However, this was only the beginning of our period of ill fate. One morning early in the seventies I woke up with excruciating pains in my abdomen. I thought it was an attack of appendicitis, and Irene telephoned our friend, Dr. George Wittenstein, for help. He came quickly, not even properly dressed, and after a brief examination he decreed that I should be moved to Cottage Hospital immediately. While I was half-unconscious with pain, a series of tests was made and George warned Irene that the situation was serious and an operation would have to take place soon. She was told to notify our two sons to come and stand by in a possible crisis. In those days I hardly knew what was going on. I remember that a glass of water always stood at my bedside and was regularly exchanged, but nobody told me that it was important for me to get fluids into my body. As a result it was suddenly discovered in one of the countless tests to which I was subjected that I was dehydrated and my kidney function had stopped. I was put on a dialysis machine, and then the nurse supervising the procedure had a bright idea. She noticed that I could hardly talk because my tongue was completely dry. She gave me a glass of water to drink and, after I greedily downed it, several more. A blood test which was made soon afterwards revealed that the kidney function was largely restored. However, I never fully recovered from the attack, and even today the after-effects are noticeable.

While lying in the hospital in a half-coma, I was unaware that I underwent a serious operation in which more than ten feet of intestine was removed. The surgery was performed by George Wittenstein while Christel, his wife, who is also an M.D., served as anesthetist. I understand that at one point Christel actually saved my life. Soon after the operation she entered my room in the hospital and found that I had stopped breathing. She immediately called an emergency team, which managed to bring me back to life. After that I was transferred to the intensive care unit of the hospital. There, as I was later told, I spent ten days. I didn't realize the passage of time, as there as no daylight in the room and lights burned day and night. Visitors, and even members of my family, were not allowed to see me. Only once my friend Roger penetrated my prison. At the door he had introduced himself to the nurse as Dr. Chapman, which gave her the impression that this musicologist was a medical doctor.

I recall two particularly unpleasant details from this time. Not far from my bed stood a contraption that produced light signals accompanied by little clicks. It greatly disturbed me, but the nurse only grinned when I complained and refused to make any changes. Much later I realized that it was my own heartbeat which was registered by the machine, thus allowing the nurse to monitor the vital functions of my body. Moreover, from time to time a physical therapist came and pounded rather mercilessly my chest and back. This was, like so many unpleasant things in life, supposedly very good for me. Possibly it helped my blood circulation and breathing.

I gradually recovered and then had to get ready for a second operation; this time surgery of the prostate gland. The result was most discouraging. I contracted a very bad infec-

tion and had to be operated upon once more. A new and more competent urologist took care of me, and this time he did a very good job.

I had hoped that at last I could now enjoy a period of comparatively good health, but it was not to be. While I liked taking daily extended walks I found that this gradually proved difficult and almost impossible. My left leg refused to cooperate, and I experienced increasingly strong pains with every movement. I consulted three different orthopedic surgeons, and they all agreed that surgical replacement of the diseased left hip joint was necessary. Dr. Peus undertook to perform the operation, and I entered the Cottage Hospital as a patient for the fourth time within half a dozen years. However, the surgery had to be postponed for one week, as my kidneys posed problems.

In these days of uncertainty there was still another cause of worry. Irene had a little wound between two toes of her right foot which refused to heal. She finally consulted a doctor, who was unable to help her. Then a surgeon had a brilliant idea: he would remove the offending toe altogether. Dr. Wittenstein supported the idea, and while I was lying in the hospital waiting for my operation the two doctors came to my room and asked me to influence Irene so that she would be prepared to undergo the operation. In the most alluring manner they described to me how nice it would be if, after both operations, we would share the same room and keep each other company. However, we vigorously opposed the idea and I was thus robbed of the pleasure of Irene's joining me.

Dr. Peus performed a very successful operation for me, replacing the diseased hip bone with stainless steel, and after a period of therapy in a heated pool and using crutches, I could walk again without pain.

As soon as I felt a little better I looked after Irene's foot. By regularly cleaning the wound and using some light bandages I gradually managed to achieve complete healing. When we told our friend George that the wound had disappeared, he didn't believe it at first. On seeing the evidence with his own eyes he declared that I had made medical history.

Our own work was, of course, strongly curtailed during these bad years. Nevertheless some projects, started at an earlier period, came to fruition in spite of ill health. My two-volume edition of Haydn's opera *Orlando Paladino* was published in the collected edition of Haydn's works, and in the same year, 1972, Gluck's opera *Telemaco* also appeared in print as a part of the Gluck collected edition. The work on the Gluck opera had been particularly difficult. No less than ten different manuscripts had to be consulted. They were mostly from the eighteenth century, but all of them deviated in details from one another. Only eight pages of the score in Gluck's own hand have survived; thus there was comparatively little secure evidence. In editing a score which, in printed form, filled 370 large pages, I had again and again to make difficult choices between versions of certain passages. I can only hope that I did not err too often in my attempt to reconstruct Gluck's masterwork.

In the following year two other projects on which I had worked for some time were completed. I had been asked to provide the chapter "The Development of Chamber Music During the Eighteenth Century" for Volume VII, "The Age of Enlightenment," of the *New Oxford History of Music*. Irene and I collected material for this challenging work in various places, especially the Library of Congress, the New York Public Library, and the Boston Public Library. This provided me with an opportunity to prove an early theory of

mine: that the baroque trio sonata for two melody instruments and figured bass was the source from which instrumental duos, trios, and quartets were derived. Egon Wellesz had invited me to write the chapters, but he was gradually incapacitated by old age, and the volume of the *Oxford History* could not appear in print. Finally, Frederick Sternfield undertook the necessary last revision and updating, and I was happy to see my study printed at last in 1973.

In the same year another project of mine came to realization. I thought it might be useful to offer a series of textbooks dealing with individual musical forms. Harcourt Brace was won for the idea, and friends of mine were willing to collaborate. In 1973 the first two volumes of *The Harbrace History of Musical Forms under the General Editorship of Karl Geiringer, University of California, Santa Barbara* were published. Homer Ulrich of the University of Maryland supplied a fine study, *The Survey of Choral Music*. It was presently followed by *The Symphony*, an excellent survey contributed by Louise Cuyler of the University of Michigan. The third book of this series of trial balloons was to be provided by Edward Downes of New York University, but he was fully occupied with other projects and we finally managed to win Robert Donington of the University of London for a volume on *The Opera*. All three scholars made excellent contributions. The volumes were handsomely printed and contained many musical examples and pictures. They appeared in paperback and were modestly priced. Nevertheless, the expected good sales did not materialize. American colleges rarely provide courses dealing with individual musical forms, and there was apparently not sufficient incentive for students to buy the texts. Therefore, we had no choice but to cancel the production of further planned volumes.

After my quadruple operations I slowly and never fully recuperated. Irene was even worse off. After the bad accident in the Austrian mountains, her foot healed, but her heart had suffered and she never quite got her earlier strength back. In order to save her some work I returned to a search I had done several decades earlier and in which I didn't require much help on her part. I completely revised my former book on the history of musical instruments, not only updating the content but prefacing every chapter with an outline of the development of music in the period under discussion. I tried to show how changing artistic and stylistic trends influenced the development of contemporary instruments while, at the same time, the construction and limitations of the instruments helped to shape the development of musical compositions. The new book, entitled *Instruments in the History of Western Music*, was printed in 1978 by my usual publishers, Oxford University Press in New York and Allen and Unwin in London. A German version was immediately commissioned by C.H. Beck in Munich, but it took several years before I was able to complete the translation.

As I was now engaged in work on instruments, I also returned to a small problem which had been on my mind for quite some time: the question of the arpeggione. Schubert wrote a beautiful sonata for arpeggione and piano, but there has always been uncertainty over what kind of instrument this "arpeggione" really was, since the term has not been used by any other musician. In an article I wrote for *Musical Quarterly* I indicated that Schubert's arpeggione was a guitar which was not plucked, but played with a bow. I also explained the choice of the instrument's peculiar name.

It was a strange coincidence that in the same year in which this article was published, 1979, my long-forgotten doctoral dissertation from 1923 also appeared in print.

Quite unexpectedly the main musicology professor of the Vienna University had written to me and asked whether I would consent to his including my work in a series of publications, *Wiener Veröffentlichungen zur Musikwissenschaft.* Unfortunately the numerous photographic illustrations which I had used for the dissertation would have to be omitted, as they would raise the production cost too much. Nevertheless, I agreed to the proposal, and it was with strange feelings that I received the printed version of work I had done more than fifty-five years earlier.

There was also another field of earlier activity to which I returned, at least partially, during the latter part of the 1970s. On the regular constitutional walks which I took in the neighborhood of our house, I frequently met a gentleman who, as I knew, was a member of the UCSB faculty. We usually exchanged a friendly "hello" without paying much attention to each other. One day, however, he stopped me and, after introducing ourselves, we started a brief chat. He was Professor Mudrick of the English department. At the end of our little meeting he said casually, "I am in my office daily from twelve to one; why don't you drop in some day when you are at the University?" I did so a few days later and found out that he was not only a professor in the English department, but also the provost of the College of Creative Studies. This is a small college for particularly gifted students who are allowed to determine, more or less, their own course of studies, working mostly with tutors, similar to the model of British universities. Mudrick asked me whether I would be interested in offering a class to the students of the college. I gladly accepted and we agreed that I would teach for one quarter.

The experiment was fairly successful, and for several years I offered courses for one quarter on different subjects

for the students in the college. The drawback, however, was that my classes remained very small. Not too many students in the tiny college were interested in music history, and some of them were lacking in the proper preparation for this specialized field. Students majoring in the music department were admitted to the classes but, as they did not receive credit for their work, they rarely came. Anyway, my teaching in the College of Creative Studies came to an abrupt end as various faculty members at UCSB rebelled against Mudrick's leadership, claiming that he used unqualified instructors at times to conduct classes. Mudrick was demoted, although he remained a full-time professor in the English department. The new provost was not interested in musicology and claimed to have no money to spare for a course in the history of music.

At this point, fortunately, the department of music came to the rescue. They remembered my former services to the department, and I have been able for quite some time now to offer a course in the department for one quarter every year. There has been no shortage of students since the music department undertook the sponsorship. However, it was not quite easy for me to always find a subject for my classes which was interesting and valuable for students while not conflicting with any other classes offered by the regular faculty members. Moreover, repetitions of the same subject were not possible, since I had some faithful students who attended my classes through several years. There was very little routine work and I had to prepare my courses quite thoroughly every year. Then there was, as always, the financial problem. The music department had no funds to spare for my teaching, and it was up to David Sprecher, provost of the College of Letters and Sciences, to grant the necessary money. David liked the idea of my teaching, but he had to

consider the needs of a large number of departments, and his own budget was also quite tight. Thus it usually happened that I had started my class and was teaching it for two or three weeks before I received my contract of reappointment and was certain to be paid for the work involved. Just the same, I am delighted thus to have had an opportunity to work with students again, and I would be happy if I could continue under a similar arrangement for another year.

While I resumed teaching on a small scale, at the same time I also intensified my activity of lecturing at different universities and attending scientific congresses. At the Brahms Conference held in Detroit I chaired the session discussing whether a new collected edition of the composer's works was advisable and necessary. I was definitely in favor of the idea, since the early edition had been done in great haste, and quite a bit of new source material has been discovered since it first appeared in print. I steered the meeting in this direction, and it was finally decided to go ahead with the ambitious plan. The important publishing firm of G. Henle in Munich was won for the realization of the project. At a later Brahms Congress, held in 1983 at the Library of Congress in Washington, D.C., I offered the keynote address, "Brahms the Ambivalent." I was only allowed twenty minutes for my paper, but the audience responded most enthusiastically and presently the address appeared in print, even before the volume containing all the papers offered at the conference was available.

In 1975 I attended a large international Haydn Conference at the Library of Congress. There I offered the first public lecture, "Haydn and His Viennese Background." Since my time was not limited, the lecture was illustrated with numerous musical examples. I also participated in several working sessions of the Congress and was glad thus to

have an opportunity to meet again with old friends working in the same field.

At a later Haydn Conference held in Vienna in 1982 I chaired the session, "Problems of Authenticity and Chronology." At this meeting I had a double function as I also read a paper contributed by my friend Robbins Landon. He was unable to attend the conference and had asked me to present his report on "The Newly Discovered Authentic Scores of Haydn's London Symphonies from the Library of Johann Peter Salomon." During the 1970s and '80s I also again attended some of the yearly meetings of the American Musicological Society, usually serving as the chairman of a session.

Apart from attending congresses, I also made repeated trips to various universities where I offered lectures to faculty, students, and invited guests. My topic was mostly connected with Bach or Brahms, but I also discussed other problems, such as the authenticity of newly discovered works by the great masters of the past. I lectured twice at Stanford University, combining the trip to Palo Alto with a very pleasant visit at the home of my son George. There were also several trips to Ohio, where I spoke at Oberlin College, Baldwin-Wallace College, and no fewer than three times at Wooster College. On these occasions I also had an opportunity to renew an old friendship with my former student Klaus Roy, program annotator of the Cleveland Orchestra. Particularly rewarding were two lecture trips to the Eastman School in Rochester, New York, and several trips to the Boston area, which I usually made in springtime. I always stayed in the very lovely and hospitable home of my charming niece Magda, who, after a long widowhood, had married Dr. Laszlo Tisza, a professor of theoretical physics, retired from MIT. Magda lives in a very comfortable house on

Chestnut Hill, where my own room with bath was waiting for me each time I came. I also saw quite a bit of my son Martin, who was teaching at Northeastern University, and of his girlfriend, Pat Cristofaro. Moreover, two former students of mine, Wilbur Fullbright, who was now associate dean of Boston University's School of the Performing Arts, and Ingrid Gutberg, a very fine organist and pianist, regularly gave large parties when I was in Boston. I usually offered two or three lectures during every visit, speaking at Harvard University, Boston University, Northeastern University, MIT, Tufts, and Brandeis University. My stay in Massachusetts was always very rewarding, and I looked forward to the trip all year long.

On my trips east I usually had to change planes in Denver. If the waiting time was long enough I notified Viola Lowen, the daughter of one of my cousins. Viola and her husband Henry came to the airport and we spent a pleasant hour or so together. Viola is a schoolteacher and a delightful person of whom I am very fond. Once, when the plane connection did not work out, she and her husband also took me hospitably into their home, where I spent a very agreeable evening and night.

In retrospect it cannot be said that the late seventies and early eighties were bad times for us. It is true that Irene steadily lost ground. Her health deteriorated, but so slowly that we barely noticed it. Her weak heart developed into real angina, which occasionally debilitated her greatly; however, our life continued without major changes. Our daily walks had to be shortened and the work schedule reduced. Our social life, which had never been particularly active, was further curtailed, and we tried to avoid any emotional strain. However, we still saw good friends like the surgeon George Wittenstein and his lovely wife, the anesthesiologist

Christel; the fine singer Ruth Michaelis and her untiring companion, Imogene Henderson; the inseparable sisters Rose and Dorothy Kissilove; the very gifted art critic, poet, and composer Stephan Lackner and his charming Austrian wife, generally known as "Puck," who produced ceramic masterworks. Most of all, we regularly met with my dear niece Helen. Although Helen lived in Pasadena, we kept in close contact with her. She has a responsible position as scientific editor at the Jet Propulsion Laboratory in Pasadena, but still manages to keep her house in meticulous order and, until his early death, lived happily with her fine husband who was active in the same field in which she is, and with her now-married daughter, Rochelle. There were, of course, now-regular visits to the heart specialist whom Irene consulted, but he was usually satisfied with her condition and assured her that she was not doing badly.

In 1982, the year before the final catastrophe, we still had two very pleasant experiences. Together with George and Janet we made a delightful summer trip to Alaska, partly flying and partly driving in a rented automobile. The weather was fine, the wonderful fjords and the titanic glaciers reaching down to lakes with icebergs swimming in it offered unforgettable vistas, and the teeming wildlife seemed hardly disturbed by the presence of men. It was one of the most enjoyable vacations we ever had.

Moreover, in the fall of 1982 George and Janet accompanied us to the Vienna Haydn meeting, and Martin and Pat, traveling on their own, joined us there. I got an official notification that the Austrian government intended to bestow a second decoration on me. However, I would have to stay an additional eight or ten days in Vienna after the end of the Haydn Congress, as the Minister of Education, who was to perform the ceremony, was out of town. I expressed polite

thanks but said I had to leave Vienna as soon as the congress was over. If they wanted to decorate me, the ceremony could also take place in California, through the Austrian consul-general in Los Angeles at a later date. As a matter of fact, I had planned an automobile trip with my children through Austria, and we wanted to leave on time so as to enjoy some leisurely sightseeing before George's and Martin's vacations ended. All our expectations were realized in the following weeks. We visited old churches, castles, and cities which had not changed much in recent centuries. We delighted in the beauty of Austria's mountains and lakes during a period of beautiful fall weather, getting as far as the western end of Austria and then backtracking through southern Germany. In Munich we stopped for our return flight home, and all six of us had the feeling that this was one of our most successful trips.

In the summer of 1983 we decided to take another trip away from mainland America. This time Martin was to accompany us to Hawaii, where we had never been before. We were impressed by some of the big tides, the rain forests, and some of the waterfalls. Most of all it was exciting to witness an eruption of the active volcano on the main island. I had been on the top of Mount Vesuvius in Italy and had been atop Mount Etna in Sicily, but both of them were inactive, whereas the fury of the Hawaiian volcano was overwhelming. Flames and smoke were erupting from the crater, and we saw trees go up in flames when they were touched by the steady stream of glowing lava.

Despite these memorable experiences we were only half-satisfied when we returned home. It certainly didn't add to our pleasure when right at the beginning of our trip, while we visited an aquarium and admired the ocean life, somebody bumped into me in the darkness of the hall. Soon

afterwards I realized that the rear pocket of my pants had been slit open with a sharp instrument and my wallet had disappeared. It contained all of our money and credit cards, and it seemed as though our trip was completely ruined. Fortunately it occurred to me to telephone my broker, Paine Webber, in Santa Barbara, who instructed the firm's Honolulu office to advance us the necessary cash to continue. Nevertheless, the loss of the credit cards created some difficulties, and it was not a good omen for the rest of our trip.

Then the blow fell. The exertion of the trip, and especially the island hopping by plane and ship with constant changes of accommodations, may have been too much for Irene. One week after our return she woke up in the morning complaining about unbearable feelings of dizziness. Her doctor, whom I immediately called, ordered her transferred to Cottage Hospital. There a number of tests confirmed my worst fears; Irene had suffered a massive, paralyzing stroke. In the next ten days her condition surprisingly improved. She regained some ability to move her limbs, and she could utter a few coherent words. It seemed to me that the various therapies at the hospital performed wonders, and I dared to entertain a little hope for the future again. However, the hospital informed us that they were not allowed to keep her any longer and that she would have to be transferred to the Rehabilitation Center for further treatment.

This seemed to be the right move, but we were rudely disappointed. I believe that the Rehabilitation Center is the best place for younger people who have lost some of their faculties in an accident; but for an old and feeble person the routine treatment of the patients was too much.

Irene's condition steadily deteriorated, and one morning I was notified that the doctors of the Center had decided to

return her to Cottage Hospital. There it presently became obvious that her case offered little hope. In addition to everything else, she had contracted pneumonia. For several days she was only semi-conscious with a high temperature. On the morning of September 23, 1983, Janet arrived to pay a visit to her mother-in-law. At four in the afternoon I left the two ladies and went downstairs to the cafeteria to grab a bite, since I had not eaten since early morning; but before I was able to begin my hurried meal Janet appeared in the cafeteria. She was deadly pale and only said: "You'd better come quickly." We ran upstairs, but it was already too late. I found Irene's room filled with doctors and nurses working on the inert body. After half an hour they gave up, and her doctor informed me that they had done everything in their power, but had been unable to achieve any success.

I was completely shattered. We had been married for more than half a century, had been friends and lovers, had worked together, shared good and bad times, and jointly brought up our children. Life alone without her presence and steady assistance was unthinkable. A kind of fog, a paralysis of thinking and feeling descended upon me. The music department of the university arranged a memorial service, at which our good friend Dolores Hsu, a wonderful person of whom I am particularly fond, spoke beautifully. Faculty members performed the lovely slow movement of Schubert's String Quintet in C major, a piece of which Irene had been particularly fond. During this concert the numbness left me and I realized the full extent of my misery. Before long, however, I returned to a state of mental paralysis.

Most of the practical aspects of my life were taken care of by Anna María Lopez, the wife of our gardener, whom Irene had already trained. I continued living in our house and

every day at noon I received some hot food from Meals on Wheels. In the morning I prepared a simple breakfast for myself, and at night I usually opened a can for my light supper. I went through all the correct motions, but felt only half-alive. It was a little bit like being a well-constructed robot that did all the right things but could not think or feel. I had to pass Irene's room several times daily in order to reach my own. Each time I felt a brief stab of pain, but then the numbness returned.

This condition lasted for well over a year; only then did the iron weights very slowly begin to lift from my heart. There were several events which helped my return to more normal feelings. I got an unexpected invitation to serve as a judge on an international Bach competition for violinists and cellists held at a music school in Washington, D.C. I had never participated in a competition before, neither as a contestant nor as a judge, and the novelty of the assignment appealed to me. I accepted, but the rules of the game I had to play for three days seemed quite surprising to me. All the contestants had to perform the same two movements from unaccompanied Bach sonatas, partitas, and suites. There were three judges: the well-known violinist Alexander Schneider, a reputed cellist from Germany, and I myself representing Bach research. The judges sat behind a partition and could not see the performers, who were only identified by numbers. We were not allowed to exchange opinions about the quality of the various renderings of the same pieces. Our duty was to give a number grade to each rendition, with zero as a failing mark and ten as the very best. Moreover, we were expected to offer written comments on details of the interpretation. The winners, who received quite substantial cash prizes, were selected on the basis of our decisions. In each case the number grades given by the

three judges were added up, and the contestant who had won the highest total received a prize. As we found out that our decisions had resulted in a three-way tie, there was a second competition among the three best performers and, on the basis of the final results, the first, second, and third prizes were assigned. At the concluding party, held at the German Embassy, we met the winners for the first time; all of them were professional young people, partly Caucasian and partly Asian. Altogether it was a memorable experience.

It was also satisfying to me that some earlier work had finally come to fruition. After I had finished the edition of the opera *Orlando Paladino*, the chief of the Haydn Institute in Cologne entrusted me with a second similar work. He asked me to edit early operatic fragments by Haydn which were preserved in the Budapest Library. As always, I had to use photographic copies made from the originals as a a basis for my work. The various fragments posed far more questions than answers, and my attempts to solve different puzzles were not too successful. It would have been most helpful if I could have consulted the original manuscripts in Budapest, but I was unwilling to undertake the much-too-complicated and tiring trip. Thus I had arrived at a dead end when Dr. Feder, the Haydn Institute's editor-in-chief, came to the rescue with the suggestion that one of his younger editors might do the necessary additional research. I gladly agreed, and Dr. Günter Thomas of the Haydn Institute completed the work. In 1985 the volume of the Haydn edition containing the problematic compositions finally appeared in print, jointly edited by Dr. Thomas and me.

In the following year another project on which Irene and I had worked jointly came to final realization. Soon after the University of California Press had published the third edition of our Haydn book we had started on a German

translation of the biography, to be published by Schott in Mainz, the firm which had already printed the first edition of our Haydn. Schott wanted to issue the new book as a paperback together with the reputed firm of Goldmann in Munich. This didn't prove to be a very good idea. The production of our book progressed at a snail's pace, since the two firms did not seem to maintain proper contact. I didn't know who was in charge, and my letters mostly remained unanswered. When I finally got galley proofs of the book they were full of printer's mistakes, and these errors were only partially corrected in the page proofs which came years later. The production of the index, which the publishers had agreed to provide, again took years and thus, only about a decade after we had delivered the manuscript, the book appeared in print. It contained all the pictures I was able to provide and a substantial number of musical examples, but it was still not free of printer's mistakes and did not look particularly attractive. I had very mixed feelings when I first received it.

Another pleasure was provided by a visit to Santa Barbara by the Austrian consul-general from Los Angeles. He brought me the Austrian decoration for meritorious services to the Austrian Republic for which I had not wanted to wait in Vienna. It was, of course, satisfying to me that the country of my birth thus conferred a second decoration on me.

A particularly nice experience at that time was Martin's wedding to Pat in 1986. The ceremony took place in a lovely church on Boston's historic Copley Place. It was arranged for my eighty-seventh birthday on April 26, 1986, when I was in Massachusetts on one of my periodic visits. Two ministers, a man and a woman, both friends of the bride and groom, performed the ceremony. The service was quite unusual, as Martin and Pat had recruited a number of

singers, including George, to join them in providing the music. Martin himself arranged the program, choosing love madrigals and sacred music with appropriate texts. Moreover, he composed quite a nice little piece for the group. The unusual feature of the wedding was that both ministers, as well as the bride and groom, joined in the singing, which was partly conducted by Martin. Relatives and friends crowded the church. The lovely day ended with a very nice party my niece, Magda, gave for the newlyweds.

BY the time Martin's wedding took place, Bernice Shapiro had already come into my life. Irene and I had known the Shapiros for many years. Monroe Shapiro was a passionate hiker, and Irene and I had met him occasionally on our Sunday excursions and exchanged a few words with him. Bernice and Irene were well acquainted, and even shortly before our ill-fated trip to Hawaii the two ladies had arranged to lunch together in a restaurant.

In 1985 Bernice telephoned me and asked for my intervention in the interest of one of her protégés, a young French conductor who was in charge of the UCSB student orchestra. He liked his position very much, but it appeared that the University did not want to renew his contract. The three of us had brunch together, and I got a very favorable impression of the young conductor. I did my best for him but soon found out that the faculty members didn't think very highly of his abilities and wanted him replaced.

While I was unable to help the young man, he helped me. I had several telephone conversations with Bernice to report about my various unsuccessful attempts on behalf of the conductor. We also met occasionally at concerts, chatting a bit together. Finally I mustered the courage to ask her

to go to a concert with me. The experiment was successful and was repeated several times. Occasionally we also had dinner with other friends before concerts.

Gradually I learned her story. Bernice's mother became a widow shortly before Bernice was born. Because she had no funds she consented to give Bernice to a childless couple, who subsequently adopted her. From an early age she showed her talent for music, and after several years of piano study she started to give recitals and won many awards.

Not having siblings or a "normal family," she entered marriage too soon, desperately hoping to have children and relatives of her own. However, nature did not cooperate easily. She lost five children to the same terrible disease, cystic fibrosis: one daughter died at eleven, the second at twenty-two and, earlier, the other three as infants. Her marriage was unhappy, and she was divorced in the same year in which I lost Irene, 1983. Bernice now has two grown sons: David, who lives in Long Beach, has a lovely wife, Lynne, and two young sons, Drew and Zane; Michael, her younger son, is a surgeon at the University of California Medical Center, San Francisco. She also has a daughter, Beverly, in Santa Barbara, who has a sweet three-year-old daughter.

Bernice and I share great love of music. As an outstanding pianist she frequently performs concertos with orchestra. She can also boast to have studied as a young girl with Arnold Schoenberg. We both love nature and physical exercise. We enjoyed each other's company and met gradually more and more frequently.

When the time arrived for a new trip to the East, we decided on the spur of the moment that Bernice would accompany me as my wife. The wedding was quickly arranged. A mutual friend of ours, Judge Joseph Lodge, agreed to perform the ceremony, and his wife, Sheila Lodge,

the mayor of Santa Barbara, would serve as a witness. On April 9, 1987, we went to the elegant home of the Lodges' on the Riviera. There was a small gathering of relatives and close friends: Bernice's daughter, daughter-in-law, and grandchildren; her intimate friend and the wife of the noted nutritionist, Ilene Pritikin, as well as Mrs. Pritikin's mother and sister. George and Janet had come from Foster City; Christel Wittenstein managed to get away from her work in the hospital; and our friends the Lachners were in attendance. The ceremony was brief but very impressive. The usual pictures were taken. We had cake and champagne. The wedding was more than a little surprising to both of us, but we thoroughly enjoyed it!

The practical arrangements we made are not exactly traditional, but we find them most satisfactory. We kept our two houses. Bernice maintains her home in Montecito, while I continue living on the Riviera. We keep in touch by telephone two or three times a day and we always have dinner together. On the four days on which Anna María comes to my house she prepares our joint dinner on Mira Vista Avenue, while on other nights Bernice cooks for both of us and we eat at Rametto Road. After dinner we spend the evening together, and in the morning she leaves to resume her piano practice in Montecito. Our whole ménage works out extremely well. The enormous difference in age— Bernice is nineteen years younger than I am—doesn't seem to bother her, and our life together is a blessing for both of us. She is a warm, gracious person and a devoted and caring wife. We always have a good time together and never seem to have disagreements.

There have been several pleasant developments since we have become husband and wife. On our honeymoon in Boston our relatives and friends constantly arranged parties.

During those memorable days we also attended an excellent performance of Berg's *Wozzeck* performed by the Boston Symphony Orchestra, and immediately afterwards a fine rendition of Bach's *St. Matthew Passion* at the New England Conservatory of Music.

In August we visited Martin and Pat in their lovely new home in rural Rhode Island. There we also saw my niece, Eva, and her husband, Nicolas Orisini, who came from their home in Connecticut to visit us. They are both very gifted artists, and I have a large abstract painting in my home which Nick gave me. Eva is a fine book illustrator and Nick a very successful university professor. I am sorry that there are only rare opportunities for us to meet with this fine couple.

After a brief stay in Rhode Island, Martin, Pat, and little Daniel drove with us to Marlboro, Vermont, where we attended the Chamber Music Festival for a week. There I had also an opportunity to renew a friendship of more than seventy years with Rudolf Serkin, the artistic director of the festival. I remember quite well having heard him perform in Vienna when he was still a little boy wearing short pants and socks which left his calves bare. In a way, Rudi's and my own early courses of study are similar. His teacher was Professor Robert, a renowned pianist in Vienna. My own instructor was Mrs. Bernstein, a favorite pupil of and assistant to Professor Robert. The results are, unfortunately, very different, since my own piano technique—at least at present—does not go very far beyond chopsticks! Now in his eighties, Serkin was still vigorous and full of life. He played the difficult solo part in Beethoven's *Choral Fantasia* with the bravura and fire of a youngster. In December of the same year I had two pleasant surprises, which I suspect were arranged by Bernice. We were invited to the City Hall where Mayor Lodge, in a public ceremony, first read aloud and then

handed me a beautiful Letter of Recognition. It lists my achievements and ends with the words:

Now, THEREFORE, I, Sheila Lodge, by virtue of the authority vested in me as Mayor of the City of Santa Barbara, do hereby express appreciation to
DR. KARL GEIRINGER
for his outstanding contributions to the world of music and for the contribution he has made to Santa Barbara by his presence in our community.

The little ceremony was followed by a wonderful concert at UCSB in my honor, to celebrate the twenty-five years I had been connected with the university and the city.

Charming introductory remarks were made by my friend Professor Dolores Hsu, whom I have known since I first came to Santa Barbara. I was privileged to be a member of the university committee that conferred tenure upon her. In 1963 she arranged for me to give a lecture in Oregon, and I stayed there as a guest in her mother's home. At present she is the chairperson of the UCSB music department, popular with students and faculty alike and admired for her fine administrative abilities.

The musical program of the celebration consisted, with a single exception, only of compositions by Bach, Haydn, and Brahms, since I had written biographies of these three composers. The one exception was a little cantata Peter Fricker had composed in my honor for tenor voice and flute quartet. He chose a rather unusual text for this work: Bach's note of dedication accompanying a Mass he sent to the Elector of Saxony. Peter presented me also with the handsome original manuscript of the composition.

Among the performers in this memorable concert were

many of my faculty friends: Robert Freeman, Geoffrey Rutkowski, Betty Oberacker, Emma Lou Diemer, Elizabeth Mannion, William Prizer, and Carl Zytowski. Bernice, Janice Trilck, and Alexander Bootzin performed the charming six-hand piano work, "Das Dreyblatt" by Wilhelm Friedrich Bach, which concluded the musical program.

I could not help feeling that this and other honors accorded to me in recent years were no longer deserved. In earlier years I had to struggle hard to get grants for my work from the Philosophical Society in Philadelphia and the Guggenheim and Bollingen Foundations in New York. It was even more difficult to be elected president of the American Musicological Society and to become a fellow of the American Academy of Arts and Science. In my old age, however, distinctions were accorded to me without any effort on my part. I was given two decorations by the Austrian government. I was made an honorary member of the American Musicological Society and of the Society's Southern Pacific chapter; of the Austrian Musicological Society; of the American chapter of the Neue Bach Gesellschaft; of the Handel and Haydn Society in Boston; and of the International Gluck Society. The Bavarian Academy of Science in Munich elected me a corresponding member; I became honorary president of the new Brahms collected edition, and Wooster College in Ohio bestowed an honorary Doctor of Music degree upon me. All of this happened at a time when my productivity had greatly diminished.

Recently, Dame Judith Anderson, who has been a friend of Bernice's for many years, was visiting us to view a video of Horowitz and presented me with a gift, a cherished photograph of one of her musical idols, Arturo Toscanini, on which she had written me a most effusive message of appreciation for the great joy I had given her through my books.

Not long afterwards, a magnificent "black tie" evening was held as a tribute to the "First Lady of the Theater," to which we were invited. Some of the most illustrious personalities of the stage and screen were in attendance. Vincent Price was master of ceremonies; James Stewart, Mary Martin, Robert Mitchum, etc., gave stirring accolades to Dame Judith; and the event was climaxed by a touching "thank you" by Judith herself. It was a very special night!

The best event happened in June 1988 when the Gesellschaft der Musikfreunde invited Bernice and me to come to Vienna as their guests, since exactly half a century had passed since Hitler's entry into Austria had forced me to leave the country. We spent almost three glorious weeks in Vienna, where we were accommodated in an elegant hotel quite near the Society's headquarters in the Musikverein. I gave two public lectures, one in the Musikverein, almost exactly at the place where I had worked fifty years earlier, and one at the Music Academy. I met quite a number of influential people, and there was a very impressive article with my picture in *Die Presse*, Austria's main newspaper. We went to concerts practically every night and once to the opera, where we heard a fine performance of Verdi's *Masked Ball*.

We found Vienna completely rebuilt after the terrible damages of the war, teeming with tourists, and filled with heavy traffic. My friend Otto Biba, who today occupies a position similar to that which I held fifty years ago, took us into the country several times in his car. We visited the impressive monastery of Melk, the beautiful medieval church of Heiligen Kreuz, and the former living quarters of Arnold Schoenberg in Mödling, where today Ernest Křenek resides. My "adopted granddaughter," Bastienne de Vivie, a charming medical student whom I had first met when she

spent some weeks in Santa Barbara as a guest at the Wittensteins, drove us in her car to Grinzing, where Beethoven had stayed, to the Kahlenberg and Leopoldsberg, and to the impressive monastery of Klosterneuburg. The Österreichische Musikzeitschrift also had timed the publication of an article I had written about the influence of C.P.E. Bach on the music of Haydn, Mozart, and Beethoven to coincide with my stay in Vienna. All this contributed to a wonderful time, and we found it difficult to leave Vienna.

The visit to the archives and museum of the Gesellschaft der Musikfreunde reminded me of an amusing episode I had witnessed there more than fifty years earlier, but which I still recall as vividly as if it had happened yesterday. Mrs. Curtis Bok, the founder of the Curtis Institute of Music, had sent us two of her former star pupils who were interested in visiting the city of Haydn, Mozart, Beethoven, and Schubert. Their names were Samuel Barber and Gian Carlo Menotti. Barber was especially fascinated by a "monster" in our collections. It was a huge string instrument, almost thirteen feet high, equipped with wire-covered strings of a finger's thickness. A mechanism operated by pedals served to shorten the strings. The instrument was built in Paris in the middle of the nineteenth century following a suggestion by Hector Berlioz, who recommended its use in large ensembles. Only three of these mammoth instruments are known to have survived, and the one in the Gesellschaft no longer had the mechanism to shorten the strings. There were few objects in our museum which intrigued Barber as much as this curiosity, and he proclaimed that he would play it. He ascended a stepladder, attached the heavy bow with string and a handkerchief to his right foot and, balancing himself on his left foot, played a simple tune by pressing his fist against the string. It sounded terrible, but he was satisfied. The experi-

ment ended by his falling off the ladder—fortunately without hurting himself—and I, who was watching, was convulsed with laughter. Some twenty years later, when Barber and Menotti had already become famous composers, I invited them to visit Boston University. Barber, who might not have wanted to be reminded of the earlier incident, politely declined, but Menotti actually came, lectured, answered questions, and had a tremendous success with the students of our College of Music.

Soon after Bernice and I returned from Vienna we had a pleasant family reunion in Carmel to celebrate the silver wedding anniversary of George and Janet. Bernice's son Michael and Martin with Pat and Daniel joined us.

Bernice's appearance as soloist with the La Mirada Symphony, where she played the MacDowell piano concerto, came shortly after and was a great success. Her brilliant performance of the difficult score won her the well-deserved acclaim from an enthusiastic audience.

This brings me to the conclusion of my memoirs. My life with Bernice works out beautifully; she is a godsend to me. I am now over eighty-nine and a half years old and not much more is likely to happen in my life. Looking back I notice both ups and downs, successes and disappointments. I have no feelings of regret. It seems to me that, as far as my fate allowed it, I have made adequate use of the modest resources with which nature endowed me.

Santa Barbara, November 1988.

Epilogue

BY BERNICE GEIRINGER

IN THE SPRING of 1988 Karl and I took a memorable trip to Vienna that was a joy to both of us as well as a deeply stirring experience. Fifty years had passed since Karl, then curator of the Gesellschaft der Musikfreunde, had been forced to leave Vienna after Hitler's march into the capital in 1938, when Austria was annexed to Germany and the doors of the society were bolted. To commemorate the fact that half a century had elapsed since these tumultuous events, the society invited us to return during the Festwochen (Music Weeks Festival), and the three wonderful weeks we spent in the city of Karl's birth have become one of my most cherished remembrances.

Otta Biba, our host in Vienna, was waiting to greet us at the airport with a beautiful bouquet of red roses. He then drove us to the Hotel am Schubertring on the Ringstrasse, where the Society had made our reservations. Otto saw to it that our days were filled with exciting activities and that our

every wish was granted. We revisited the magnificent palaces and museums, drove out into the beautiful countryside around Vienna and, more importantly, Karl held press conferences, had radio interviews, and delivered lectures at the Society and at the Hochschule für Musik. Almost every evening we attended concerts at the Musikverein, hearing the London Philharmonic, the Prague Philharmonic, and, of course, the incomparable Vienna Philharmonic. The performances included the artists Vladimir Ashkenazy, Carlo Maria Giulini, Peter Schreier, and Nikkolaus Harnoncourt, all of whom Karl had known over the years. We even sat in the same box that Karl had occupied when he was curator of the Society's collections.

We lunched with Eva Badura-Skoda, the distinguished musicologist, and later Otto took us to the Schoenberg house in Mödling, where we visited with Ernest Křenek, who was currently living there. Seeing Schoenberg's home was particularly meaningful to me because I had been Schoenberg's first student when he came to California. Karl also enjoyed touching reunions with relatives, colleagues, and other friends. We dined at the home of Karl's cousin, who prepared delicacies that Karl particularly liked, among them Tafelspitz, which is boiled beef with spinach and potatoes, and Palachinken, paper-thin, sugared Austrian crêpes. We even went to see the home on Sieveringgasse where Karl had lived with his parents, and with Irene, when they were newly married. On earlier stays in Vienna he had felt that such a visit would be too emotional an experience, but this time he really wanted to show me where he had lived as a young man.

On our last day in Vienna, Austria's leading newspaper, *Die Presse*, ran an impressive article on Karl, accompanied by a photograph of him. The article ended with these words:

"People of all ages have been moved, for they have seen the man who is the history of music himself."

When we returned to Santa Barbara Karl seemed ready to start writing his memoirs. We spent the ensuing months working together almost daily on the manuscript. He enjoyed working outdoors on the patio in the warm sunshine, surrounded by a brilliant profusion of color—red bougainvillea, yellow hibiscus, and pink ivy geranium—and enjoying the lovely fragrances that emanated from the flowers and from citrus and other fruit trees in the garden.

What a joy it was for me to relive Karl's life with him! Recapitulating his life from his earliest years up to the present brought back to Karl's consciousness many incidents that even he had forgotten and that were meaningful to both of us.

Karl's dedication to scholarly pursuits was inexhaustible. His background in the humanities was broad and extensive; the visual arts, literature, history, classical art—all were branches of knowledge that held never-ending fascination for him. He was an avid reader, vitally interested in everything that was going on, and always ready to participate in lively discussions on many topics. Needless to say, his devotion to the work in his chosen field was deep and abiding. To the end of his life he worked consistently and methodically, considering his work to be a privilege and a labor of love.

Karl loved to teach, and his students revered him. He was a friend to colleagues and students alike. He never quarreled with anyone; rather, he tried to build bridges for others, if need be. He maintained relationships with many of his students throughout the years, and he was never too busy to respond to their letters or to write detailed letters of recommendation for them. Not long ago, when we returned from a concert, there was a message on our answering machine: "This is your pupil, Robbie, calling to see how you are."

The caller was the famous H.C. Robbins Landon, who has been a close friend since he was Karl's student at Boston University.

Karl was in his element when he was invited to give lectures at colleges and universities. He was an excellent speaker, with a deep and resonant voice and a careful, distinct delivery. He had a colorful vocabulary, and his accent, with its broad A's and its Germanic flavor, always added to his presentations. He had a fine sense of humor, and his wit was always evident when he spoke. To me he always looked distinguished; though he was no Beau Brummel, he dressed with refinement. He had a good sense of color, and he always wanted to be neatly groomed.

Since early youth Karl had an authentic love of nature. He was a dedicated mountaineer and had frequently climbed high peaks in Europe and America. As a young boy he had often walked with his father, in winter putting his hand in his father's pocket, holding his father's hand for warmth. On the daily walks that Karl and I took, we carried on the same tradition: holding hands, inside his pocket if it was cold, or, if it wasn't, we held hands just because we wanted to.

Karl was truly a cultured, civilized gentleman of the old school. In our everyday life he would never put a fork to his lips until we were both ready to start our meal, and when we returned home he unlocked the door first and always allowed me to precede him. His manners were not a superficial veneer, but a reflection of his genuine care and concern for others. Karl enjoyed people, whether it was in a one-to-one relationship or in a group. He was an excellent host, putting everyone at ease with compelling and amusing anecdotes.

I have never known anyone who gave to as many charitable causes as Karl did. He could not afford to donate large sums, but he sent regular contributions to seventy-five or a

hundred charities. He could seldom deny a good cause, and he often acquired items for which he had little use.

Karl's gentleness was also expressed in his fondness for animals. For many years Clyde, a dog owned by Ruth Michaelis, the well-known contralto who lived nearby, would be waiting every day to accompany us on our walks. Then there was the black-and-white cat who thought she belonged to our house. That worked well until the cat decided that Karl should share his Meals-on-Wheels lunches with her. If the meal was left on the porch when we were not at home, she simply helped herself to what she wanted and generously left the rest for Karl. He, however, was unappreciative, and we had to arrange to have the lunch left elsewhere.

In August 1987 Ilene Pritikin, who has been like a sister to me, drove us to the airport when we were heading east for the Marlboro Festival. She picked us up on a beautiful sunny Santa Barbara morning. Karl happily quipped, "Heaven smiles when angels travel." He was very fond of Ilene, but he drew the line at following the diet guidelines advocated by her husband, Nathan Pritikin. Ilene had invited Karl and me to spend several weeks at the Pritikin Center in Santa Monica. Karl thanked Ilene graciously and told her he appreciated the invitation. Without committing himself, he sweetly said, "Bernice will be happy to go." Karl, a bit of a maverick when it came to his diet, indulged in certain foods that he knew were not good for him and rationalized his lapse by saying that a little bit wouldn't hurt.

Karl was really looking forward to the Marlboro Festival, where he would see his friend Rudolf Serkin, director and guiding light of the festival. It was a joy to see their reunion, warmly embracing and kissing each other. How wonderful, they said, it was to remember early times! As they talked, a flood of memories of childhood days poured forth, as well as

of other encounters during the years that followed. They continued to share their recollections in the dining hall or elsewhere, whenever they had the opportunity to talk during the ensuing week. Although their areas of specialization in the world of music were vastly different, they had deep respect for each other. They were delighted to have the opportunity to spend time together.

The chamber music concerts at Marlboro, performed by professional soloists in collaboration with upcoming young artists, were exceptionally fine. The high point of the festival is always the last concert, when Serkin plays the Beethoven *Choral Fantasy*. Those attending the festival are encouraged to sing in the chorus, and even I made my singing debut while Serkin brilliantly performed the work. The concerts, amid the natural beauty of rural Vermont, and the pleasure of being with Rudolf Serkin, made the week a particular treat for Karl and me.

Karl was devoted to the memory of Irene, his first wife and his collaborator, to whom he had been married for many years. On her birthday and on the anniversary of her death we always went to the cemetery and placed fresh flowers on her grave. Karl was also a deeply caring father; his twin sons, George and Martin, who were always in close contact with him, and their families were a source of great pride to him, and their accomplishments brought him much pleasure. Karl loved his grandchildren dearly. From the time they were very young he sent them an allowance and remembered their birthdays well in advance to be sure the gifts would arrive on time. Karl was very fond of my two little grandsons, Drew and Zane, who live in Long Beach; for youngsters aged two-and-a-half and five, they were very well-mannered, a trait Karl really appreciated. My granddaughter Ramona, who is now just four years old, lives in Santa Barbara, and she

adored Grandpa Karl. Often he would surprise her with a gift he had ordered from a catalog. Even when she was very young, he would bring her over to have dinner with us; we kept her highchair in our home on Mira Vista. Now, when she and I drive along the street where Karl and I lived, she always says, "That's where you lived with Grandpa Karl. I loved him; I wish he was here now."

Words are inadequate to express the beauty of my relationship with Karl. I felt that each day we shared was a special gift, for which I was very grateful. He would often say he felt he was "home" when we were together. His wish was my command, and conversely, before I even completed a request to Karl he interrupted with an affirmative reply. We spent the early part of each day in our respective areas of commitment, Karl writing and I working at the piano; the rest of the day we were always together. He said he looked forward all morning to our working together later afternoons and to our leisurely dinners and evenings, when we listened to music, viewed the inexhaustible library of travel slides he had taken, attended concerts, or visited with friends. Sunday was our special day, a day of rest and fun. We took longer walks than usual, frequently in the foothills above Santa Barbara. In the summertime we often walked barefoot along the water's edge at the beach, an outing Karl particularly liked. When we returned home he loved to prepare blueberry pancakes, his special culinary achievement. Later in the day we often saw a movie or did whatever suited our fancy. Sunday evening we usually had dinner at one of our favorite restaurants, and that was the day.

Although Karl's fame evolved as a music historian, he also had some training as an instrumentalist. He had originally studied the violin, but switched to the viola when he found he would have more opportunities to play as a violist. He

particularly liked concerts of chamber music, symphonic music, and operas, but facetiously he said, "I only like piano concerts when you play." One day Dusi Mura, my piano coach for many years and a dear friend, brought the eminent pianist Andras Schiff to our home because Andras wanted to meet Karl. He cordially invited us to his concert that evening and, somewhat reluctantly, Karl went. The program included the Bach "Goldberg Variations." Karl was very impressed with Schiff's playing, and at the reception he praised the pianist effusively, even enthusiastically.

Another pianist who visited us about that time was Ruth Slenczynska, who had come to Los Angeles to judge in a competition. I had first heard her play many years ago when she was a child prodigy. Later, her mother married my uncle and she became a member of the family. Ruth, who had never met Karl, was looking forward to it. As her trip west brought her close to Santa Barbara, this was the perfect opportunity for them to meet. Having known about Karl and his work for years, Ruth was delighted to meet "Dr. Karl." Our Bösendorfer concert grand with its full rich tone, which had originally belonged to Karl's aunt in Vienna, fascinated Ruth, and she had a field day playing that beautiful instrument for us.

Lenard Stein, director of the Schoenberg Institute, invited Karl and me to the Institute's 1987 annual meeting. Both Karl and I had had long-time associations with Arnold Schoenberg. While I was studying with Schoenberg as a private scholarship student, John Cage and George Trembley also became his pupils and he taught counterpoint to the three of us. By then he was also teaching at UCLA and, as I was a pianist, he asked me to go with him to his classes and assist him by playing examples from Beethoven sonatas.

While we were at the Schoenberg Institute, Karl and I agreed to participate in a video the institute was making. Karl

spoke about his memories of Schoenberg from the Vienna days and about his attendance at rehearsals of Schoenberg's Chamber Symphony. At each rehearsal Schoenberg would take just a few sections, talk about them, and then go on. It was only after the ninth rehearsal that the orchestra played the entire work from start to finish without interruption. Karl also attended numerous concerts at the Musikverien when new works by Schoenberg were being performed. The audience would get very excited; there would be yelling and fistfights, and at times the police had to be called in. During the pandemonium, Schoenberg, Webern, and Berg watched from the balcony, radiantly happy. They were having the time of their lives and didn't mind the upheaval at all. They thought it was great fun to know that Schoenberg's music created such a strong reaction. Recently I was delighted to receive a copy of the video from the Institute, for it showed Karl looking happy and animated as he spoke of his recollections of Schoenberg in Vienna.

Karl was very supportive and enthusiastic about my career as a pianist. Often he would listen to a new composition I was studying to see how it was progressing. He was a valuable press agent for me, telling our friends far in advance about an upcoming recital or an appearance with a symphony orchestra. Several months before he died, Karl and I attended a chamber concert with an all-Mozart program conducted by Heiichiro Ohyama. Shortly after the performance, Karl suggested to Ohyama that an all-Haydn program would be a splendid undertaking, as Haydn's music was not played often enough. At the same time he proposed that I play the Haydn D-Major Concerto. The performance did take place, but not in the manner we had anticipated.

After I had given Dame Judith Anderson a copy of Karl's book on Brahms, she told me it had opened the doors to the

world of music for her, and she has been everlastingly grateful to Karl. She enjoyed reading the book so much that she gave it to her family and friends to read, and then she herself read it and reread it again. As a child she had taken piano lessons, but she gave it up after a short period of time because she felt that playing the piano didn't allow her to show off as much as she would like. She always knew she was a show-off, so she started taking elocution lessons and that led her to the perfect milieu for her, the theater, where she could be "center stage." From there she went on to take center stage as the "First Lady of the Theater."

One afternoon we invited Dame Judith over to our home to see a video of Vladimir Horowitz. Both Horowitz and Toscanini had been her friends and musical idols since she had met them long ago at the home of Charlie Chaplin. Because of her esteem and admiration for Karl, she wanted to bring him something close to her heart, a possession she really valued. The gift she brought on that occasion was a cherished photograph of Toscanini which he had given her.

Karl and I were invited to a gala celebration in Dame Judith's honor which took place just about a month before Karl died, and which was attended by a large group of film notables. Normally Karl and I watched very little television, but one program Karl did enjoy was "Mystery!," hosted by Vincent Price, who was one of the guests. Karl thought it great fun to see and talk to him in person. Jimmy Stewart, Mary Martin, Bob Mitchum, Jim Prideaux, Zoe Caldwell, and Bob Whitehead were all there to participate in the festivities. As the evening came to an end, Judith eloquently acknowledged the tribute to her, bringing all the guests to their feet to applaud this illustrious great lady of the theater. Karl enjoyed the evening tremendously, even saying that it had been worth enduring the discomfort of wearing a tuxedo.

Karl's ninetieth birthday was approaching and, unbeknownst to Karl, I had already spoken to Dolores Hsu, chair of the music department, about arranging a celebration in his honor in April. As always, she was enthusiastic about the proposal. I kept thinking to myself, what a wonderful surprise the birthday celebration would be for him and how thrilled he would be.

For my birthday in April Karl had surprised me with a CD player, and on the card accompanying the gift he had written, "To my sweetheart, darling Bernice." Then he quoted from "Of the Bird's Pasture" by the twelfth-century poet Walther von der Vogelweide, who, Karl said, had anticipated his own feelings when he wrote: "'I am yours and you are mine, of this you can be sure. You are locked in my heart, the key is lost. You must eternally remain in it.' Your devoted husband, Karl." In this tender, loving message Karl intuitively expressed my feelings for him as well as his for me. I hoped my plans for his ninetieth birthday would give him as much happiness as he had given me on my special day.

Early in October Karl was so eager to teach that he had already talked to Dolores Hsu about a class he planned to offer in the winter or spring quarter on the Bach cantatas. He was also looking forward to lecturing at other universities. Roland Jackson, dean of Claremont's music school, had invited Karl to speak at the graduate school, and on December 1 Karl's lecture, "The Young Brahms and the Schumanns," was received with enthusiasm. The music department hosted a dinner for us at a restaurant in Claremont, and the faculty members and graduate students present were clearly fascinated by Karl. They kept plying him with questions which he thoroughly enjoyed answering.

Just three days after the Claremont lecture, Karl fell and hit his side on the edge of a towel rack. Though he was in a

great deal of pain he was reluctant to have me call an ambulance. He finally agreed, but before we left he insisted that he be properly dressed. At the hospital it was discovered that he had broken a rib, which necessitated his staying there for a few days. When he left the hospital we were told that he would improve more quickly if he moved around and walked as much as possible; the exercise would also help to prevent pulmonary complications. Although the activity was very painful, Karl did what was asked of him. We took our daily walks and also continued to work on his autobiography. We wanted to finish it, at least in a preliminary form, so that we could distribute copies to family members as Christmas gifts. We reached our goal and on December 22, 1988, I took the manuscript to be photocopied.

Through the month of December it became more and more difficult for Karl to take walks, but he kept trying. Several times when he lost his balance and fell I helped him up and we continued our walk. His breathing became a serious problem. By the Wednesday before Christmas Karl was already so ill that he could hardly walk without my assistance. With a superhuman effort he mustered his strength and insisted that our housekeeper, against her wishes and without my knowledge, drive him to the music store so that he could buy Christmas gifts for me. She later told me that she almost had to hold him up at the shop while he slowly picked out CDs for the CD player he had recently given me. Christmas Day, for us, was sad and quiet, as Karl was very weak. His son George, who had come to help out about a week before Christmas, was with us. Martin had also planned to join us at Christmas, but unfortunately he was delayed by flight cancellations and did not reach us until the next day. Of course I had gifts for my beloved husband, and he gave me the CDs; on the gift card he had written, in a

barely legible hand, "For my darling Bernice, to the best in my life, from your husband."

The day after Christmas Karl could scarcely breathe, and after much persuasion he reluctantly agreed to return to the hospital. There his condition went from bad to worse. I was with him day and night; Martin and George's wives (Pat and Janet), Karl's niece Helen, and other family members also came to be with us. My daughter, Beverly, who also lives in Santa Barbara, was in constant attendance at Cottage Hospital. In the next few days the doctors tried many procedures, but to no avail.

The morning before Karl died, my son Michael and his friend, Gayle, both physicians, came from San Francisco to see how he was doing. He brightened up when he saw them and even took a little nourishment. Later in the day, hoping that he would rally, I told him about our plans for his ninetieth birthday and that we were hoping to have a chair established in his name at UCSB and to have the music library named for him. Despite his weakness he could still hear me and could understand what I was saying. Several hours later, even with a certain sense of humor, he said at two different times, "When will they baptize the library?" Later that night, though he was extremely low, at one point he became quite alert and nonchalantly said, "You know, I would like to go and have dinner at home now." I agreed and said, "Fine." And then a few minutes later he asked, "When are we going?" I replied, "Very soon." Those words were the last he spoke, and he drifted off into sleep. A few hours later, on January 10, 1989, he was gone.

In the last paragraph of his autobiography Karl had written, "I'm eighty-nine and a half years old and not much more is likely to happen to me." Karl's intuition was right on target—"Man proposes, God disposes."

As Karl had requested before he died, his ashes were buried in the family plot at the Santa Barbara cemetery, overlooking the ocean that he had loved. The burial was accompanied by a beautiful memorial service in the cemetery chapel, at which George and Martin and other members of the family expressed their deep sorrow and grief. George and Martin had selected some of Karl's favorite recordings, which were played during this very moving service.

Though Karl is gone, his spirit and legacy live on.

SADLY, the event that was going to be a celebration for Karl's ninetieth birthday was instead a memorial concert, held on a date close to his birthday. Heiichiro Ohyama, conductor of the recent all-Mozart chamber concert and a faculty member at UCSB, was in charge of the program. Colleagues, friends, students, and family came from near and far to pay homage to the man who had touched their lives in so important a way. The service was deeply moving and reverent. After Dolores Hsu had delivered a touching eulogy, Karl's son George read excerpts from Karl's books. Karl's daughter-in-law Pat sang several Schubert songs, accompanied on the piano by Karl's son Martin. The rest of the program included compositions by Bach, Beethoven, and Haydn, performed by faculty members. Karl had told me he wanted Bach's "Es ist Genung" for his memorial, and it was performed by the chamber orchestra and the choral group from UCSB. Ohyama had asked me if I would play the Haydn concerto, as Karl had requested. Of course I agreed. Just before I went on stage someone whispered to me: "Play your heart out; wherever he is he'll hear you." And I think he did.

In June 1988, when Karl and I were in Vienna, every time we visited the Gesellschaft der Musikfreunde we went into

his former office and looked across at the beautiful Karlskirche. On those occasions he shared with me experiences he had had in that very room as he looked out at this magnificent church. We had a small drawing of the Karlskirche made by a friend of Karl's in Vienna many years before. After Karl died I had the drawing remounted, and now I have it close to my piano where I can look up at it when I practice and admire its timeless beauty. But, far more important, I remember how much Karl enjoyed this view, how often he looked out at it when he was curator at the Society, and how wonderful it was for us to see it together on that memorable trip to Vienna.

Several months after Karl died I attended the annual meeting of the American Musicological Society in Austin, Texas. I was overwhelmed by the outpouring of love from Karl's colleagues and friends. The name of Geiringer was magical. It evoked countless expressions of gratitude and esteem from professors attending the conference. Among them were such remarks as, "I quoted from Karl in my book," "I use his books constantly in my teaching," "Karl was the link between the Vienna of Schubert, Schumann, Brahms, Mahler, and America," "There was just one Karl Geiringer," "The world will miss him; he was a giant," and "Karl's work will carry his name over many generations." Hearing these heartfelt tributes from many academic scholars was truly music to my ears.

How I cherish the blessing of being with Karl! Our relationship encompassed the joys of young love and the depth of feeling that comes with the mature years. It was an experience that immeasurably enriched my life and brought me the greatest happiness and fulfillment.

Index of Persons and Institutions

Compiled by R.N. Freeman, Alicia Doyle, and
students of Music Bibliography, UCSB, winter 1992

Index

Index

Merritt, Arthur Tillman, 125
Metastasio, Pietro (1698–1782), 44
Meyer, Dean, 86-87
Miall, Bernard, 60, 106
Michaelis, Ruth (1909–89), 150, 166
Michigan, University of, 159
Milder, Dr. Walter, 91-92
Miller, Frau von, 59
Milton Academy, 97
Mises, Richard von (1883–1953), 25-26, 120-21
Missoula, University of, 153
Mitchum, Robert (b. 1917), 179
Mizler'sche Societät, 116
Mozart, Wolfgang (1756–91), 34, 50, 100, 113, 142, 180
Mudrick, Marvin, 161-62
Munich University, 140-41
Music Academy of the West, 99, 153
Musikfreunde, see Gesellschaft der Musikfreunde
Musikverein, see Gesellschaft der Musikfreunde
Mussolini, Benito (1883–1945), 69

Nagel, Wilibald (publisher), 57
Neue Bach Gesellschaft, 178
Neukomm, Sigismund (1778–1858), 143
Neumann, Werner, 114-15
New England Conservatory of Music, 176
New York Public Library, 129, 138, 158
New York University, 159
Norden, Hugo, 87, 92
Northeastern University, 149, 165
Northwestern University, 153
Norton, W.W. (publisher), 110-11, 129
Nottebohm, Gustav (1817–1882), 59

Oberacker, Betty, 178
Oberlin College, 164
Ochs, Siegfried (1858–1929), 37
Ohyama, Heiichiro, 196
Orisini, Eva, 176
Orisini, Nicolas, 176
Oxford University Press, 57, 106-07,

112, 116-18, 151, 160
Pannini, Giovanni Paolo (c. 1691–1765), 44
Pergolesi, Giovanni Battista (1710–36), 42, 45
Peterson, Martha, 137
Peuerl, Paul (c.1570–1625), 45
Peus, Dr. J. Carl, 157
Pfitzner, Hans (1869–1949), 57, 64
Philadelphia Philosophical Society, 178
Philadelphia Public Library, 61
Philharmonischer Chor, 46
Philharmonischer Verlag, 46
Piatigorsky, Gregor (1903–76), 131
Piston, Walter (1894–1976), 124
Plamenac, Dragan (1895–1983), 139
Pohl, Carl Ferdinand (1819–87), 51, 56, 59, 108
Pollaczeck, Hans, 25
Posch, Isaac (d. c.1622), 45, 145
Presser Co., Theodore (publisher), 146
Preussische Staats-Bibliothek, 36, 117
Price, Vincent (b. 1911), 179
Pritikin, Ilene, 175
Prizer, William, 178
Putney School, 97-98

Rachmaninoff, Sergei (1873–1943), 57, 60
Radcliffe Glee Club, 124
Ravinia Music Festival, 153-54
Read, Gardner (b. 1913), 87, 92
Redlich, Hans (1903–68), 132
Reese, Gustave (1899–1977), 35, 128, 145
Reger, Max (1873–1916), 111
Reid, Bonnie, 147
Reinhardt, Max (1873–1943), 37, 55
Rhode Island, University of, 148
Richter, Hans (1843–1916), 50
Rilke, Rainer Maria von (1875–1926), 121
Robert, Richard (1861–1924), 176
Rohrer Verlag, 60
Roosevelt, Theodore (1858–1919), 85
Root, Edward, 85, 122

203